IMAGES
of America

FOLSOM
CALIFORNIA

IMAGES
of America

FOLSOM
CALIFORNIA

Folsom Historical Society

ARCADIA

First Printed 1999.
Reprinted 2002, 2003, 2004.

Published by Arcadia Publishing,
an imprint of Tempus Publishing, Inc.
Charleston SC, Chicago, Portsmouth NH,
San Francisco

Printed in Great Britain.

Library of Congress Catalog Card Number: 99064974

For all general information contact Arcadia Publishing at:
Telephone 843-853-2070
Fax 843-853-0044
E-Mail sales@arcadiapublishing.com

For customer service and orders:
Toll-Free 1-888-313-2665

Visit us on the internet at http://www.arcadiapublishing.com

CONTENTS

ABOUT THIS BOOK

The Folsom History Museum houses a most interesting collection of photographs from Folsom's past, acquired from many sources over the last 25 years and providing a fascinating glimpse into our community's history. This photographic history book is a reflection of the photographs in the museum's collection, and as it does not document every aspect of Folsom's history, nor will this book. Although not created as a comprehensive history of Folsom, the images and tales contained within these pages will illuminate Folsom's unique and colorful heritage. We hope you enjoy it!

This book is the result of a dedicated committee of volunteers who culled through thousands of photographs and researched the story behind each selected photo. Without the efforts of one particular volunteer during the past several years, a book of this type would not be possible. Much appreciation goes to Julie Bowen, the museum's volunteer photograph coordinator, who valiantly dedicates herself to safeguarding and organizing the photo collection. Additional committee members include Candy Miller, Nordell Hill, June Hose, Darlene Falconer, and Joanne Burkett. A special note of gratitude goes to Joanne for contributing her time and talent to pen most of the book's captions.

The original historical research conducted by Cindy Baker was of immense value in producing the text of this book. Through the years, Cindy's discovery and understanding of Folsom's unique history has benefited the entire community. Her creative talent and generous spirit have resulted in numerous informative and captivating exhibits at the Folsom History Museum. We greatly appreciate her assistance with this project.

We also owe our appreciation to many people in the community who have helped, but we would be remiss if we did not thank Jack Kipp, Sue Silver, Tom Hickey, Mary Otis, Artie Davies, Sharon Fait, Dallas Grenley, Bob Lawrence, and Evelyn Kline. Jesse Duran assisted the committee by donating his professional skills to photograph the museum's original images in preparation for publishing. Likewise, the graciousness of Rebecca Gregg, Chair of the Photography Department at Sierra College in Rocklin, California, to allow us to use the department's facilities helped our efforts immensely. Finally, the enthusiasm, encouragement, and support received from the Board of Directors of the Folsom Historical Society made this project happen.

These individuals contributed the commendable qualities of this book. Any fallacies or omissions within this book are my responsibility.

Annie Anderson
Director, Folsom History Museum

Note to Researchers: This book should not be used as a literal resource.

AN OUTLINE HISTORY
OF FOLSOM

The Folsom area was first home to Maidu Indians, hunters and gatherers who lived peacefully along the Yuba and American River drainages. They called themselves "Nisenan," meaning "from among us, on our side." With the Gold Rush era, however, the Native-American population began disappearing as miners and commercial activities displaced the native societies from the rich river valleys.

Gabriel Moraga was the first person of European descent to explore the region, camping in the Folsom area in October 1808. American trapper Jedediah Strong came in April 1827. Smith's initial expedition led the way for other trappers who arrived in the 1830s to hunt beavers along the American River. In 1844, California Governor Manual Michaeltorena granted this territory to William Alexander Leidesdorff, a San Francisco trader. The land grant included 35,000 acres of land known as Rancho Rio de Los Americanos. At Leidesdorff's death in 1848, this undeveloped property passed to the estate of his mother.

With the discovery of gold in 1848, the Folsom area saw the development of several communities whose prosperity was tied to the presence of gold. One of the earliest mining camps established was Mormon Island, located at the juncture of the north and south forks of the American River. Within weeks after gold was found at Sutter's Mill, a small group of Mormons was taking gold at Mormon Island. By 1853, Mormon Island boasted a population of 2,500. Eventually, the completion of the railroad to the town of Folsom led to the decline of Mormon Island, and by 1880 the town had nearly vanished. This area is now under Folsom Lake.

Other mining towns of significance that developed in Folsom's vicinity included Negro Bar, a mining camp on the south bank of the American River. Prairie City was a sizable town with over 2,000 people during the 1850s. As the gold ran out, town residents moved on to other places, and by 1865 the town was gone, hardly leaving a trace of its existence.

Joseph Libby Folsom, a captain in the U.S. Army, arrived in San Francisco, and by 1849 he became interested in acquiring California land rich with the promise of gold. He soon left for the Danish West Indies to seek out the heirs of Leidesdorff's property. He contracted with Leidesdorff's mother to purchase his San Francisco holdings, as well as the Rancho Rio de Los Americanos, for $75,000. However, upon his return to San Francisco, Folsom found his right to the title of the property contested and became caught in a legal tangle that lasted for years.

Meanwhile, Folsom hired Theodore Judah and two other engineers to survey the land near the mining camp of Negro Bar for a railway and a township called Granite City. Folsom died in 1855 before he could see the development of his property; however, in February 1856, the Sacramento Valley Railroad completed its first train excursion from Sacramento to the new town of Folsom, renamed from "Granite City" to "Folsom" in his honor.

With the arrival of the railroad, Folsom prospered as a transportation hub and gateway to the Mother Lode. Stage and freight lines running to communities throughout the gold country met the train in Folsom. Sutter Street became the center for merchants, hotels, and commerce, as well as the terminus for the Pony Express from July 1860 to July 1861, allowing the Pony Express rider to transfer the mail carried in the mochilla to the awaiting train. During the 1860s, visitors and residents of Folsom came from around the world. For example, Folsom was home to one of the largest Chinese populations on the West Coast. The town's newspaper, the *Folsom Telegraph*, has been in continuous publication since 1856, albeit under a variety of names.

With this strong beginning, Folsom saw significant developments in subsequent years. In 1880, Folsom Prison was established as the second penitentiary in the state. The Folsom Powerhouse completed the first commercial transmission of electricity over a long distance (22 miles) on July 13, 1895, when electricity was sent to Sacramento. The Folsom Powerhouse remained in operation until 1952. Early gold mining methods were replaced by dredges that extracted millions of dollars of gold from the Folsom area. The Natomas Water and Mining Company operated dredges in Folsom from the 1898 to the 1960s, greatly influencing the development of this community.

In recent years, Folsom has experienced tremendous growth, as city services to a growing population are exceptional. Community traditions, celebrations, and recreational activities are enjoyed by many Folsom residents. The influx of high-tech oriented corporations reflects Folsom's innovative past and has contributed to the favorable economic conditions within our community today.

One
SUTTER STREET

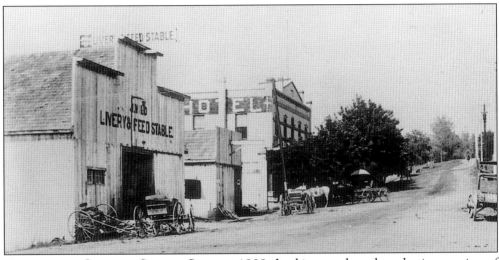

TURN-OF-THE-CENTURY SUTTER STREET, 1908. Looking northward at the intersection of Sutter and Riley Streets, Johnnie Wild's Livery and Feed Stable is visible on the near left. Later, the Hoxsie Ford dealership occupied the space until the mid-1960s. The Enterprise Hotel, built in 1893, stood next to the blacksmith shop. The first recognized hotel, the Empire, was actually located in Negro Bar. Other hotels included the Central Hotel, the American Exchange Hotel, and two different Granite Hotels (one of which was also operated as the Hotel De France). Then there was the Olive Branch Hotel, the Patterson Hotel, the Wheeler House (also known as the Mechanics Exchange), the Tremont House, the Union House, the German Hotel (which burned and was rebuilt as the New Western Hotel), and the Mansion House. Most were two-story, frame structures. The town's newspaper, *The Folsom Telegraph*, and the American River Press occupied a vacant lot on the right by the 1940s. In an 1865 edition of *The Folsom Telegraph*, Mrs. H.B. Waddilove placed this advertisement: "Patterson House. Corner of Reading and Leidesdorff Streets, Folsom. The undersigned respectfully announces to her numerous friends and the traveling public that she has leased the above well-known house, and is now prepared to receive all that may favor her with their patronage. And she assures her patrons that no pains will be spared to make it a FIRST CLASS HOTEL."

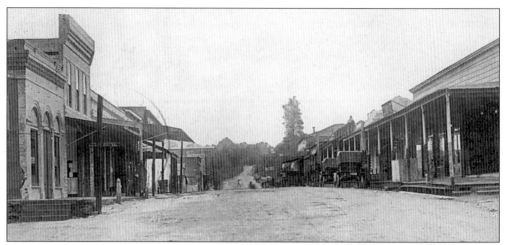

Sunday Morning, c. 1914. This is how the 700 block of Sutter Street appeared around this time period. It was probably early on a Sunday morning—otherwise the street that sliced through the town's active business district would be bustling with activity. Notice there are no utility poles, except for one on the left with its top cut off. Apparently the photo finisher removed them.

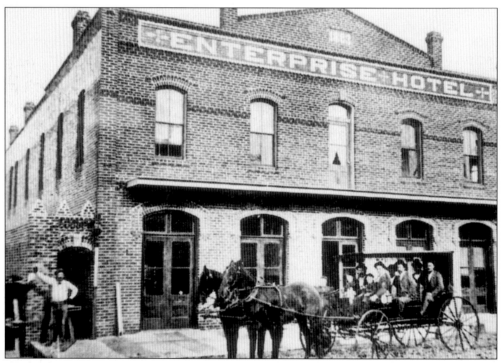

Early Hotels Did Big Business. Kate Foster, a hard working and shrewd businesswoman, was proprietress of the Enterprise Hotel. Considered a large hotel in its time, the Enterprise, in operation by 1893, was renowned for its cleanliness and close proximity to the train depot, so travelers from throughout the state frequented the popular establishment. It had a central garden with croquet lawn, and weddings were held in the lobby. Kate's son, James Donnelly, who also served the town as constable and manager of the livery stable and blacksmith shop, assisted her.

A FAMILY-OPERATED HOTEL. John Graham, pictured standing at the right with his wife, Amelia Meyer Graham, and their children, Ed, Ira, and baby Hazel, built the American Exchange Hotel in 1875. The two-story, frame construction of the American Exchange was typical of most hotels built in Folsom, although a few were constructed of brick. In 1892, the hotel burned in one of the last major fires in Folsom.

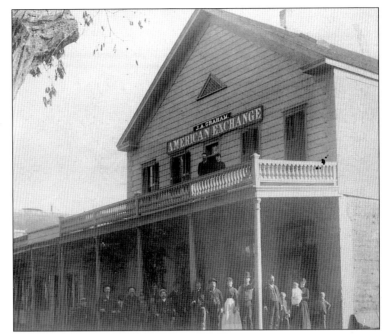

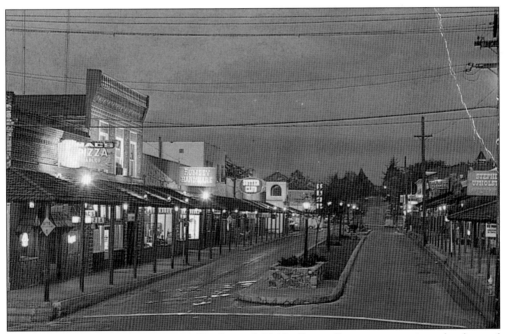

A MORE MODERN SUTTER STREET. By the mid-1960s, Sutter Street was sporting a landscaped median strip. Today, the tiny trees shown here on the strip are all grown up, lending shade to the picturesque street. Holidays and special events find the street adorned in festive decorations, while thousands gather to celebrate during its many special events, such as the annual peddlers fair, spring and Christmas craft shows, and the Christmas Illuminarios.

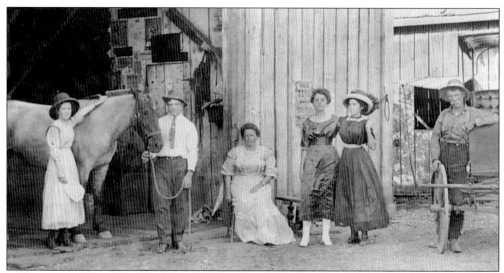

THE VILLAGE BLACKSMITH. Early Folsom citizens gather in front of a blacksmith shop. Folks always gathered there to discuss the weather and politics and curious children loved to watch him work. The blacksmith held one of the most important positions in town. His work held the town together, whether it was keeping the horses well shod or repairing farm tools and equipment.

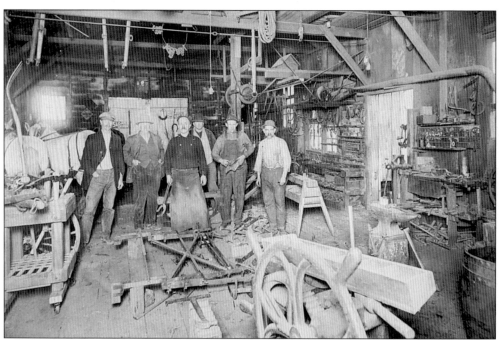

CRUICKSHANK'S BLACKSMITH SHOP. William Cruickshank, pictured center, opened a blacksmith shop on the present site of the Folsom History Museum in 1910. He was a Scottish immigrant who brought his wife, Catherine, and daughter to America around the turn of the century. The couple eventually had eight children. In addition to his blacksmith shop, Cruickshank also stored ice in the building, delivering it to homes and businesses around town. Later, Paul Murer and Red Brugler operated the People's Garage in the same building.

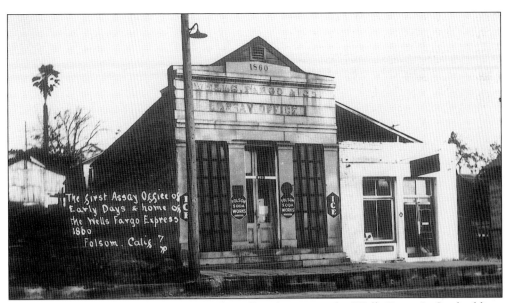

THE PALMER & DAY ASSAY OFFICE. This office, known as the Wells Fargo & Co. building, located at 823 Sutter Street, was built in 1860 by C.T.H. Palmer and Roger Day who were Wells Fargo agents, assayers, and bankers. It also served as the western terminus for the Pony Express from July 1860 to October 1861. In 1959 it was dismantled to make way for a service station. The historic building's granite facade and iron doors were saved when the Folsom Historical Society reconstructed it and rededicated it in 1976. It opened as the Folsom History Museum in 1983. Today, the museum serves as headquarters for the society, and is home to permanent, as well as changing, exhibits. As this photo shows, the building also housed the Folsom Soda Works at one time.

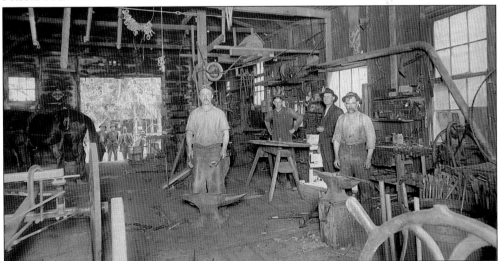

ANOTHER VIEW OF CRUICKSHANK'S BLACKSMITH SHOP. A blacksmith's job was much more involved than just hammering on a set of horseshoes, although horseshoe making was an art in itself. An ill-shod horse was of no use to anyone. William Cruickshank's blacksmith shop was no exception. He created tools and other equipment necessary to the operation of the community and its ranches, such as hoes, plowshares, cowbells, awls, scrapers, and plane blades, to name a few.

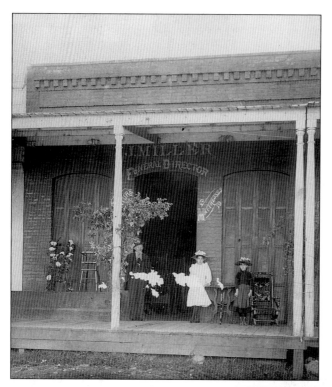

JACOB MILLER. This photo of Jacob Miller and his nieces was taken in front of his business around 1880. The business would remain a Sutter Street fixture for nearly 50 years and remain the Miller family livelihood for nearly 100 years.

FURNITURE AND CASKETS. In 1869, German immigrant Jacob Miller opened a furniture and casket-making business and a livery stable on Sutter Street. The family business would survive nearly 100 years. By 1880, Jacob was a full-time undertaker. In 1920, his son Oscar moved the business to Scott Street. Lee Miller, Oscar's son, took over operation of the business from 1940 until he sold it to Robert Claney in 1962.

SPRINGTIME WAS FOR HATS. Three Folsom ladies wearing fancy hats pose modestly during the spring of 1912 in front of the Bank of Folsom, which was located on the corner of Sutter and Wool Streets. Sutter Street, the central part of town, was where everyone came to conduct business during those days.

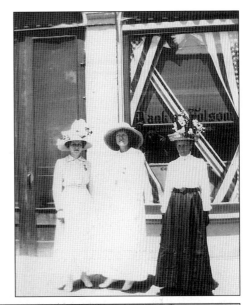

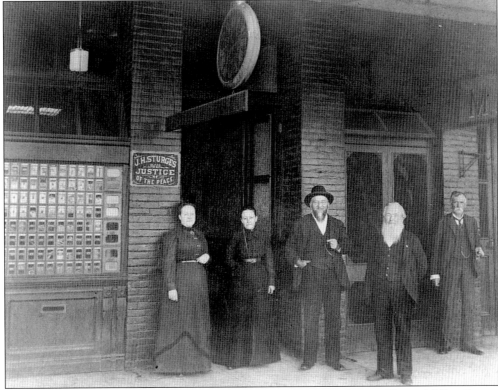

BUSINESS IN FOLSOM, ABOUT 1870. Pictured from left to right are Hattie Miller, Louisa Klumpp, Christian Ecklon, Judge J.H. Sturges, and James H. Burnham in front of Sturges' office at 721 Sutter Street. In addition to being Justice of the Peace, Sturges did business as a watchmaker and jeweler. Ecklon ran the Granite Market and also owned Folsom's cable suspension toll bridge. Burnham worked at a variety of occupations, from fire insurance agent to pharmacist. His home still stands near Sutter on Scott Street.

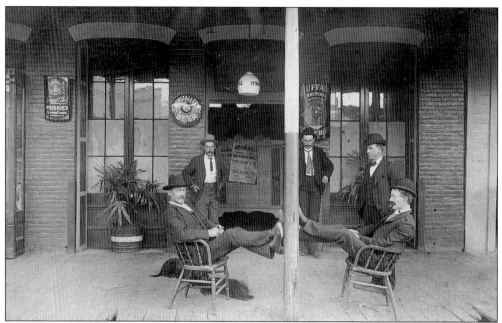

FRONTIER COMFORT. Five unknown gentlemen create what looks like a scene straight out of a western movie. Notice the newspaper on the swinging doors. The men may have been the proprietors of nearby businesses, which included hotels and restaurants, saloons, pharmacies, a variety of stores, blacksmith shops, doctors' offices, and others.

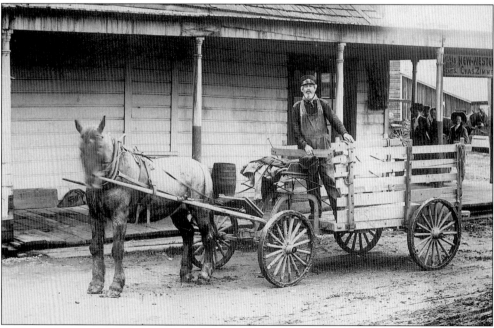

A HOTEL ENTREPRENEUR. German immigrant Charles Zimmerman came to Folsom in 1872 at the age of 30. He bought a hotel and store at Sutter and Wool, rented out the store, and ran the "German Hotel." In 1880, he built the three-story New Western Hotel at Sutter and Riley. He is pictured here in front of the hotel in 1890. Rooms went for $1 a day.

LIFE HAD ITS LITTLE REWARDS.
In the early 1900s, all the
delectables of the day could be
found together on the 700 block
of Sutter Street at J.H. Norton's
Pioneer Bakery, which included
an ice cream parlor, a candy
counter, and cigar shop.

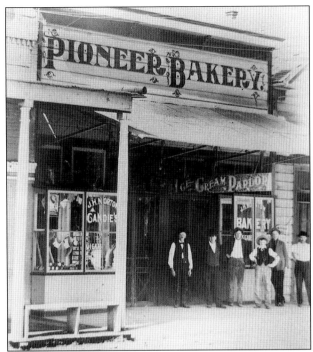

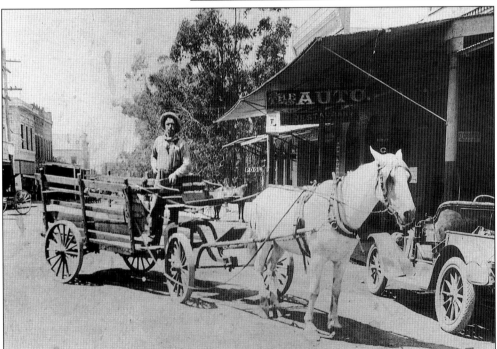

ALL IN A DAY'S WORK. Bill Nichols, pictured here around 1910, was a drayman. Since 1856, Folsom has been a rail center and stage depot, and all the mining communities connected with the Sacramento Valley Railroad at this location. Whether hauling baggage to the stagecoaches and trains, or transporting freight to other locations, a drayman was one of the busiest men in town. The building next to Bill is Rumsey Hardware.

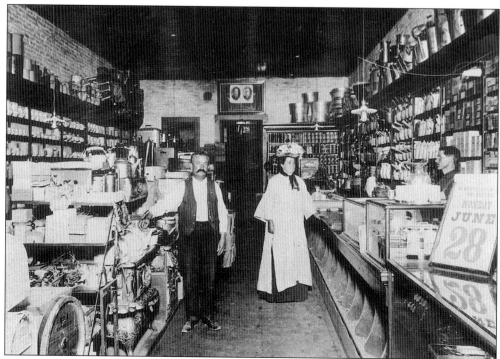

IMHOFF'S GENERAL STORE, 1909. At George Imhoff's General Store, located on the 800 block of Sutter Street, one could buy a kitchen stove, a mailbox, a coffeepot, nails, and canned goods. Mr. Imhoff stands in the aisle while a member of the Burnett family helps a customer in a festive bonnet. The building later housed the Thurman sheet metal shop, but has been Hop Sing's Palace restaurant since 1983.

HOME DELIVERY. Holding the reins, George Takemier and Leslie McDonald deliver groceries in Philip C. Cohn's Grocery delivery wagon around the turn of the century. Thomas Caduff owned the saloon behind them. A cold beer cost just 5¢ back then.

A Day in the Life. The child playfully seated on top of the stack of milk bottles in front of Rumsey's grocery store was a member of the Casten family, the owners of a Folsom dairy farm. After its conversion to a hardware store, Rumsey's added a sporting goods department that included a full line of fishing supplies and outdoor clothing. Bill Rumsey, who was an avid hunter, lined the two long walls of the store with deer heads.

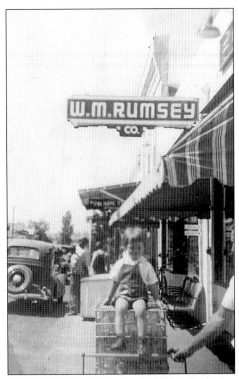

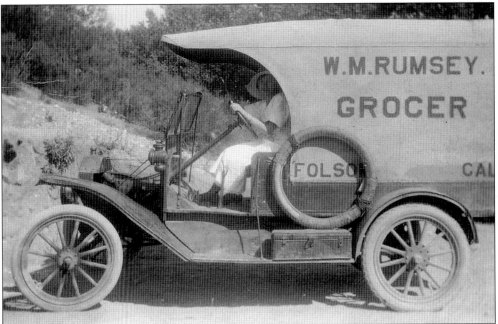

A Horse-Breaker Turned Grocer. Clara Rumsey McBeath proudly sits at the wheel of her father's delivery truck around 1920. W.M. (Matt) Rumsey came to Folsom in 1890 to work breaking horses. In 1913, he bought the Cohn grocery store, located at 724–726 Sutter Street. It later evolved into a hardware store, and Matt's son Bill, born in 1896, eventually took over and expanded the business.

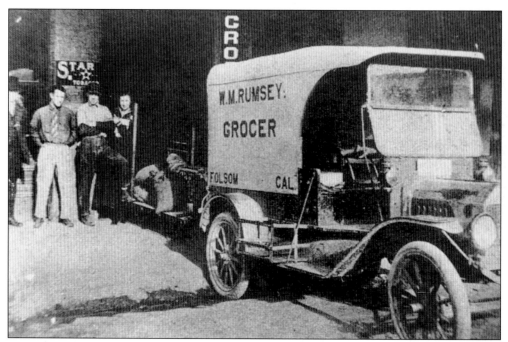

RUMSEYS AND FRIENDS. Pictured from left to right, George Jorgensen, owner Bill Rumsey, Lloyd Smith, and Bill's sister, Alice Rumsey, stand in front of Rumsey's Grocery next to a four-wheel handtruck that could be loaded with goods and pushed all the way through the store on a track. In front of them sits the company's hand-cranked Ford with its collapsible windshield.

RUMSEY EMPLOYEES AROUND 1940. Rumsey Hardware employees gathered for a staff portrait. Owner Bill Rumsey, pictured standing on the far left, was once known as the "official historian" for old Folsom.

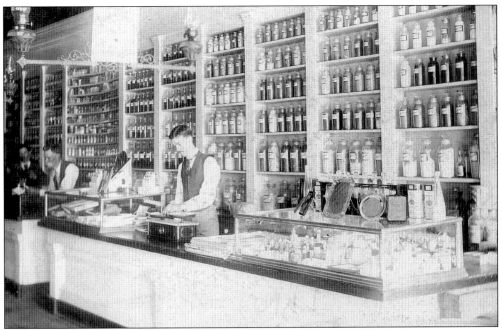

A DRUGSTORE WITH A LONG HISTORY. Originally opened in 1853 by the Burnham family, this drugstore saw many owners over the years. Subsequent owners included the Garretts, and Lee Barton and Al Relvas, who moved the business to East Bidwell Street in 1957. They sold it to the Econome brothers in 1961. The store's original safe from 1853 is now at the Folsom History Museum.

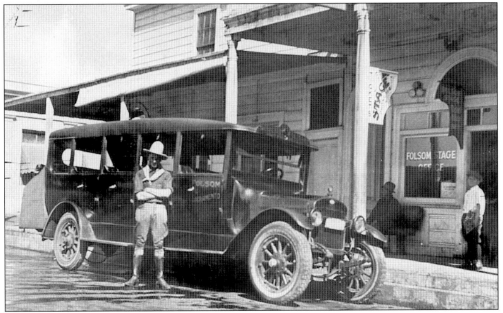

A DAPPER STAGE DRIVER. The first motorized stage line in Folsom was started in 1917. During the 1920s, the Folsom Stage office was located inside the Folsom Hotel, which was owned by Joe Murer and located on Sutter Street near Riley. The man visible in front of the car wearing jodphurs and a campaign hat was a stage-line driver.

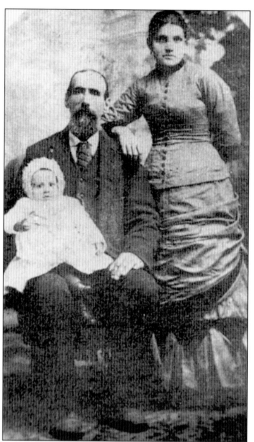

GOLD FEVER REACHED THE AZORES. The lure of gold brought Manuel Joseph Relvas from the Azores, located off the coast of Portugal, to Folsom in 1863. At left, Manuel and his wife, Isabelle, show off their baby, Joseph M. Relvas, who became the father of Abe and Al Relvas. Abe operated the Sutter Club for many years and Al owned Model Rexall Drugs until 1961.

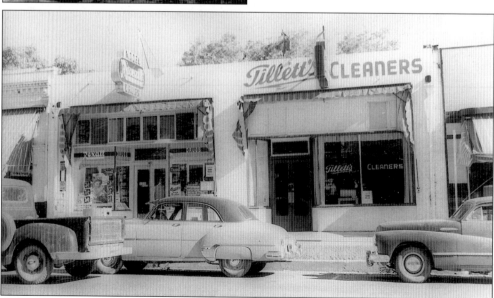

BUSINESS IN THE 1940S. Business in Folsom was good in the 1940s. Pictured here is Tillett's Cleaners and Model Rexall Drugs, located on the south side of the 700 block of Sutter Street. In its heyday, the drugstore's soda parlor was the place to cool off on a hot summer afternoon.

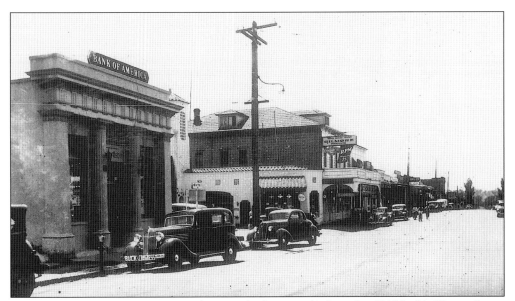

A Street Scene along Sutter. This view looking south along the 600 block of Sutter Street was taken in the early 1940s. Today Bob Baker Realty occupies the Bank of America space. The building across from the Bank of America building was a gas station built and owned by Folsom builder Guiseppe Murer.

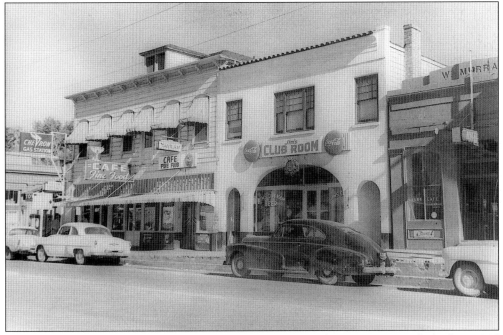

The Folsom Hotel. The building with the "Cafe-Fine Food" sign was originally built in 1885 as the New Western Hotel. Later renamed the Folsom Hotel, it is currently being renovated as a residence hotel, restaurant, and bar. During the 1880s, additions made the New Western a three-story hotel, complete with a ballroom, 22 bedrooms, a bar, reading and sitting rooms, a washroom, a laundry, and a tailor shop. Guiseppe Murer, who bought the hotel in the early 1920s and completely renovated the interior, operated the hotel for many years.

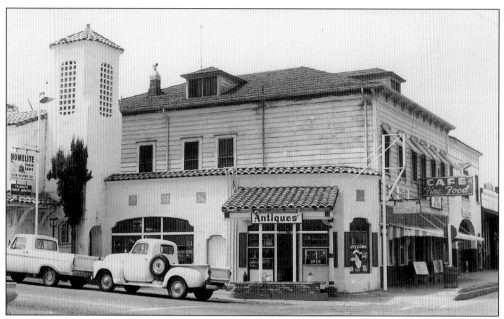

An Early Gas Station. By the 1960s, this little gas station on the corner of Sutter and Riley Streets was gone. Guiseppe Murer built the station in 1926, later using the middle room as a liquor store. After closing the station and moving the liquor store to a new building he erected across the street, he rented out the building to a succession of businesses from antique stores to art galleries.

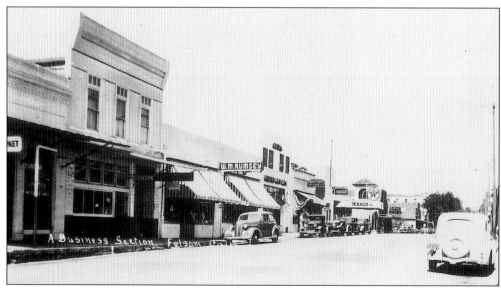

A Treeless Sutter Street. This view looking at the north side of the 700 block of Sutter Street shows how the area appeared in the 1940s. The street looks wide without the charming tree-covered median strip that runs down the center today.

Two

WORK LIFE

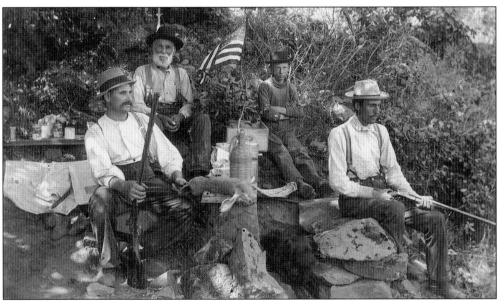

NEW YORK RAVINE, 1910. Taking a break at New York Ravine in 1910 are, from left to right, Carl Newbourg, Arthur Moore, Claus Bock, and Charles Anderson Jr., along with a pet dog. During California's gold rush period, gold mining camps dotted the landscape along the American River. New York Ravine was located a few miles northeast of Mormon Island.

GOLD! GOLD! The year was 1848 and the cry of "Gold!" was heard throughout the world. Cowboys, drifters, bankers, clerks, farmers, merchants, newly discharged soldiers, gamblers, and teenagers—all instant miners—poured into California. Thousands of them scurried along the rivers and creeks of the Sacramento Valley foothills, forming settlements and bringing gold fever with them. Everyone needed supplies, food, and other necessities, so commerce in the area blossomed. In 1849, the seed of the future town of Folsom was germinated.

By 1850, nearly every foot of the American River and its tributaries was being explored. The Folsom Mining District was placer mined from the height of the gold rush until the 1960s.

In the 1890s a primitive grab dredger began its excavations in the Folsom area, and by 1898 mining was being done by a bucket-line dredging operation. The majority of the dredging companies merged in 1908 into the Natoma Consolidated of California.

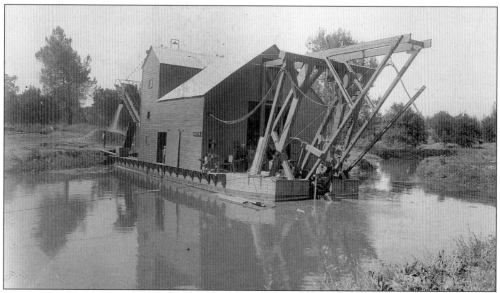

A NATOMA COMPANY DREDGE. As far back as 1851, the Natoma Company has played a role in Folsom history, providing water, granite quarrying, agriculture, vineyards, and hydro-electric power. After the turn of the century, Natoma began gold dredging operations and an estimated $100 million in gold was taken from the Folsom area. One dredge crewman said, "If you want to know hard work, work a shift on a dredger."

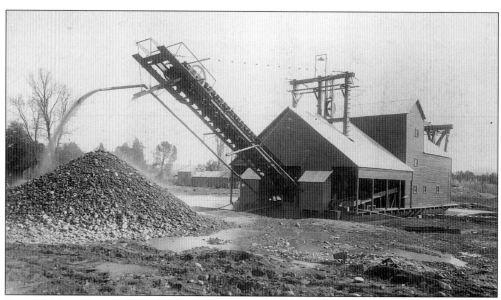

THE UNITED STATES NO. 1 DREDGE. This dredge, state-of-the-art in its day, cost about $30,000 to build. A 40-h.p. steam engine enabled its crew of two to operate it for 24 hours on three cords of wood. Fine particles of gold, normally lost with the use of the old clamshell or steam shovel dredge, were saved with this dredge. A newer model, the Natoma Eight, cost $250,000, and during its Folsom sojourn was the largest operating dredge in the world.

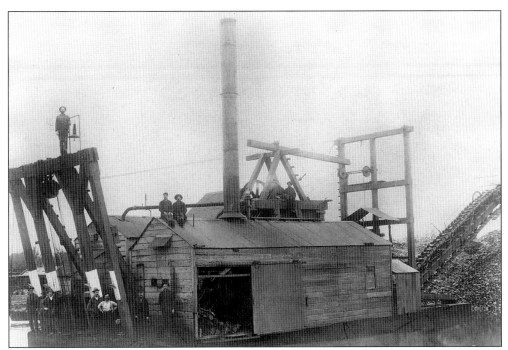

NATOMA COMPANY EMPLOYEES. Dredge workers posed along the deck and on top of the structure. Dredgers varied in size from 75 to 160 feet long, and usually needed about 20 men to operate. The Natoma Company employed up to 300 at its peak of operation, including summer stints by local high school boys. During operation, the dredges retained the gold, discarding a tailing of rock and silt more than 20 feet high.

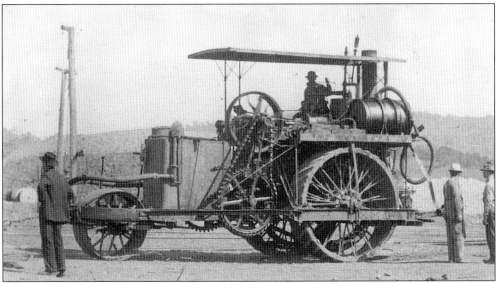

A STEAM TRACTOR, 1900. Henry Pennock sits atop a Natoma Company tiller wheel steam tractor. Henry and Jim Bates rigged up a blade on the front of an old "cat" and used it to create passable roads over the rock piles on which to take men and equipment to the dredges. Henry drove and Jim sat up front, "screwing down" the big blade, smoothing and rearranging the rocky surface of the road.

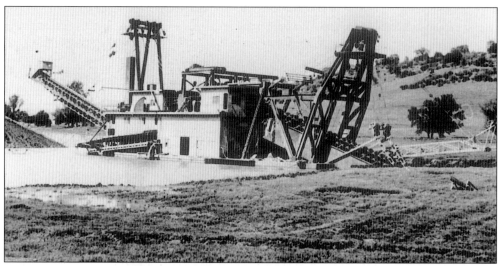

GOLD DREDGE NO. 7, 1949. Later, the Natoma Company built ditches to dredge the area from the American River's south fork to where Rancho Cordova now stands. Around the turn of the century, gold dredging technology was imported from New Zealand, prompting extensive dredging in Folsom. In 1962, the last of seven working dredgers was dismantled and sent to South America.

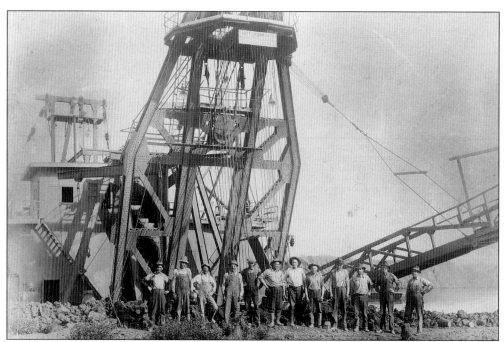

HARDY DREDGEMEN, 1900. In this crew, the man third from the left is identified as Jim Young. Operating a dredge, a few men could quickly excavate an area that would have taken earlier gold miners years to uncover working with picks and shovels or gold pans.

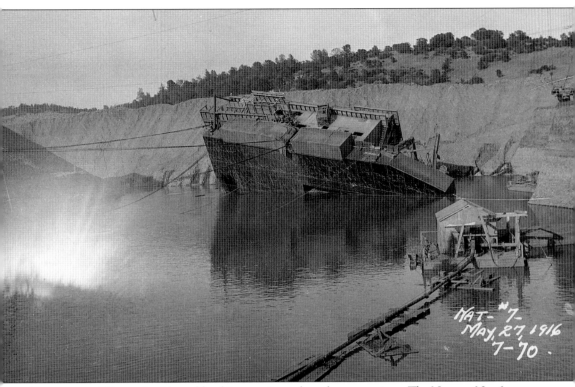

DANGEROUS WORK. Accidents like this sometimes slowed up operations. The Natoma No. 6 was nearly 159 feet long, 58 feet wide, and 11.5 feet deep, plus overhangs, and weighed a total of more than 2,500 tons. Exposed machinery and deafening noise meant the long hours of gritty work required a man's undivided attention. Companies sought ways to improve the dredges' safety.

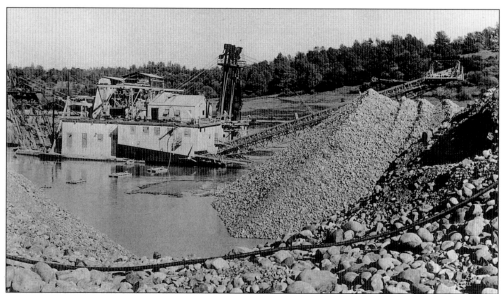

A MIGHTY DREDGE, MARCH 1949. This photograph of Gold Dredge No. 9 shows it at work in valley pastureland near Folsom. (Photograph courtesy of the United States Department of the Interior, Bureau of Reclamation.)

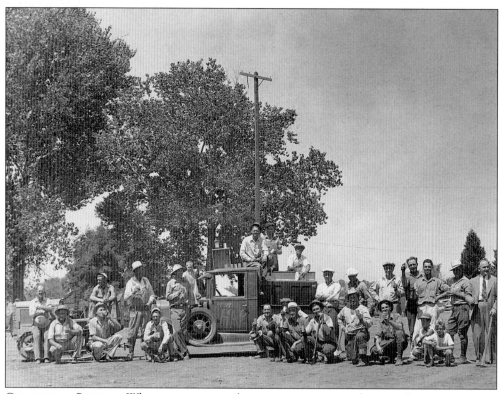

COMMUNITY SERVICE. When a town wanted civic improvements, they usually formed a work group and did it themselves. These men built the Natoma softball field. Here they take time out from their work to pose in front of "Hap" Thurman's truck.

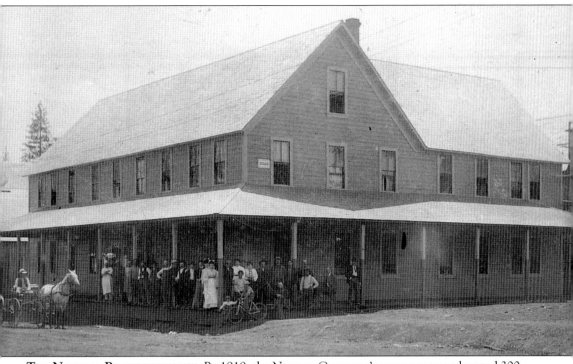

THE NATOMA BOARDINGHOUSE. By 1919, the Natoma Company's company town boasted 300 residents, many of whom worked on the dredges and in the rock crushing plant, Natoma No. 1. Office buildings, machine shops, 30 cottages, a boardinghouse, and three lodging houses were located on the site where Folsom Boulevard and Blue Ravine Road meet today. In addition to this original company, it organized two subsidiaries, the Folsom Rock Company, which erected and operated a large rock crusher at Natoma, and the Folsom Machine Company, which erected the original shops at Natoma where repairs were performed on Folsom Development Company dredges.

There's speculation that the Armour Packing Company held controlling interest in the Folsom Development Company. Armour's signature color was yellow; thus, all the buildings in Natoma were painted yellow. As a result, the company's employees were called the "Yellow Town Kids."

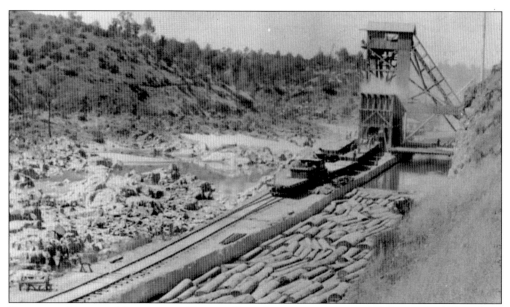

POWER TO FOLSOM. Maine native Horatio Gates Livermore came to California in 1850 seeking gold. He saw the possibilities of the American River for logging and developing hydroelectric power for industry similar to New England, where water had long been used to operate factories. To gain river rights, he bought 9,000 acres of land and donated some 350 acres to the state prison board in exchange for convict labor. In 1893, he built the first Folsom dam, canal, and powerhouse that would supply needed electricity to the prison. In this photo, logs move down the prison canal while rock-crushing equipment operates. A locomotive with rock cars transports crushed rock out for such uses as road surfacing.

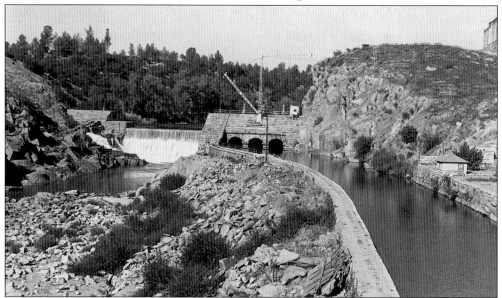

FOLSOM'S FIRST DAM, BUILT AT FOLSOM PRISON. In October 1889, prison inmates began dam construction, using granite blocks quarried on the prison grounds. Water was turned into the canal and the prison powerhouse became operative on January 16, 1893. (Photograph courtesy of the U.S. Department of the Interior, Bureau of Reclamation.)

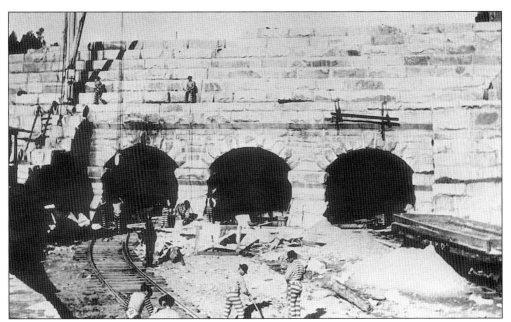

CANAL HEADGATES. This structure, the right wing of the prison dam, served to control the water flow into the canal during construction. The design of the arches is similar to those built into the 1895 Folsom Powerhouse.

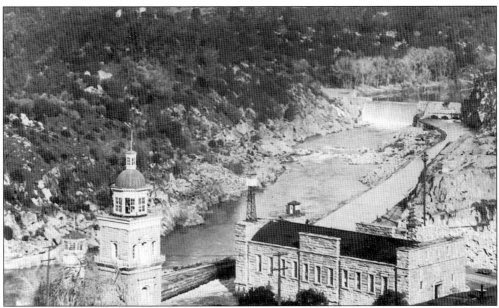

A DISTANT VIEW OF THE PRISON DAM AND HEADGATES. The building on the lower right was the original prison powerhouse that took water from the canal through an 8-foot fall, which generated electric power for prison use, and then returned the water to the canal. Power generation at the prison eventually ceased and was supplied by the Folsom Powerhouse.

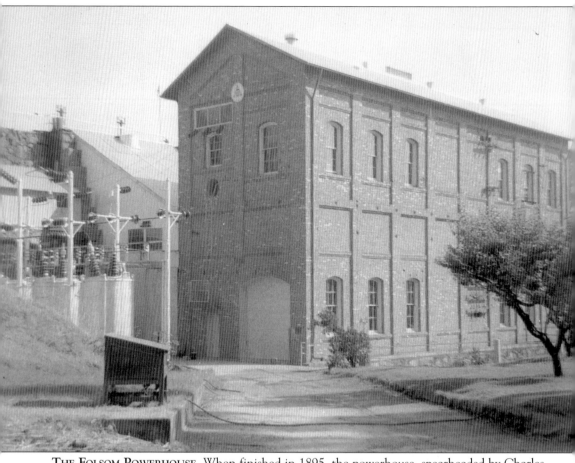

THE FOLSOM POWERHOUSE. When finished in 1895, the powerhouse, spearheaded by Charles E. and Horatio Putnam Livermore, was hailed as "the greatest operative electrical plant on the American continent." Today it is the only 19th-century hydroelectric plant that is nearly intact and open to the public. In 1973, this historic plant and its surroundings—a site of about 12 acres—were added to the National Register of Historic Places. In 1978, the American Society of Mechanical Engineers dedicated it as a National Historic Mechanical Landmark. In January 1982, Secretary of the Interior James Watt announced the elevation of this monument to National Historic Landmark status.

This photograph, showing the Pacific Gas & Electric Company logo on the building, dates from before the plant closure in 1952, when the Bureau of Reclamation started construction of the present-day Folsom Dam powerplant.

Brought online July 13, 1895, by the Sacramento Electric Power & Light Company, the firm merged in 1903 with California Gas & Electric Corporation, predecessor of PG&E.

Donated by PG&E to the state of California in 1958, the site was designated the Folsom Powerhouse State Historic Park in 1995 at its centennial celebration.

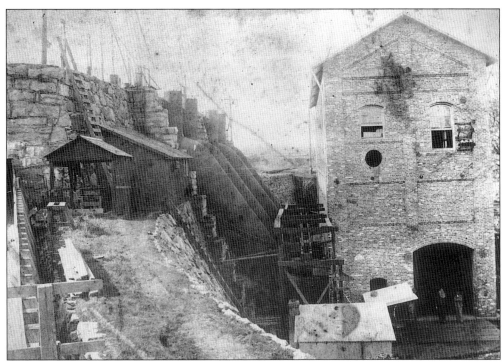

POWERHOUSE DETAILS. One of the earliest pictures of the Folsom Powerhouse shows interesting details. At the top of the bank on the left, the structure against the wall of the forebay is a pump house built after converting the hydraulic lifting mechanism for the penstock (large pipes) gates from water to oil. The use of water in the hydraulic rams, used to lift the heavy gates, was soon abandoned reportedly due to freezing in winter. The small building with the brick chimney on the lower level was the first superintendent's office.

WEIRS AND VENTS. The forebay carried water from the canal, which brought water from the old Folsom Dam, 1.5 miles upstream from the powerhouse. (Photo courtesy of State of California Department of Parks and Recreation.)

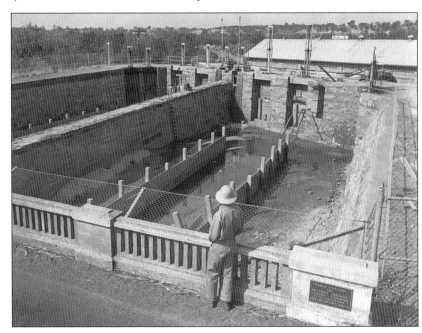

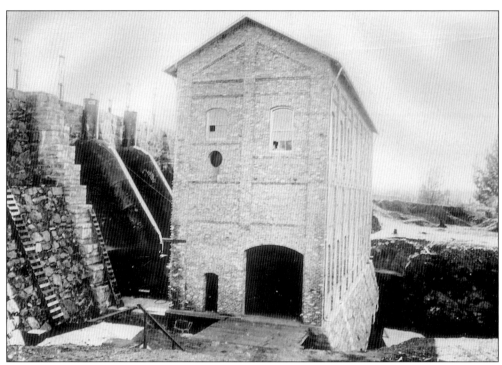

PENSTOCKS AND TURBINES. This view of the Folsom Powerhouse shows the penstocks and turbines open and exposed to the weather. The area was later enclosed. Water, stored behind the wall at left, first passed through the penstocks, then the turbines, and finally dropped under the building and returned to the river.

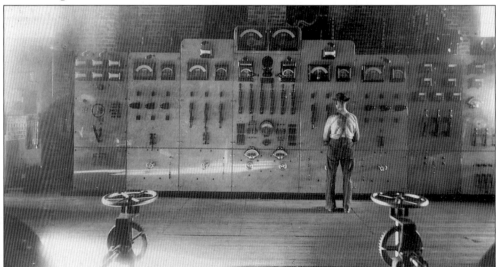

THE CONTROL SWITCHBOARD. Faced with Tennessee marble, this switchboard is another part of the original equipment still intact today in the historic powerhouse. Marble, a good non-conductor, was the standard material for such panels at the time the plant was built. Most of the switches were replaced with safer enclosed models. Also visible are the original electric meters, all mounted in wooden boxes. Seven of the original meters are still on the board. (Photo courtesy of State of California Department of Parks and Recreation.)

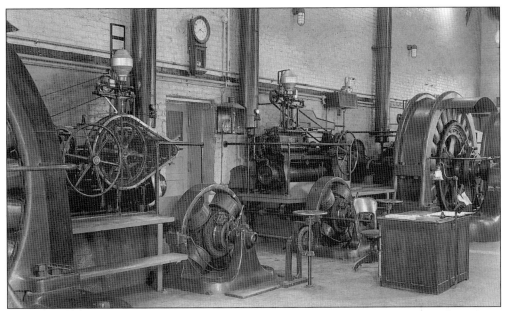

FURNISHING THE POWER. A turn-of-the-century view of the powerhouse's ground floor shows two small machines mounted directly behind the operator's desk. They are the dynamos that furnished the direct current (DC) required to energize the magnets in the large alternating current (AC) generators. Their own individual turbines drove these dynamos. Adjacent, on the raised platform, are the governors that regulated the turbines in order to maintain a constant speed, a separate one for each generator.

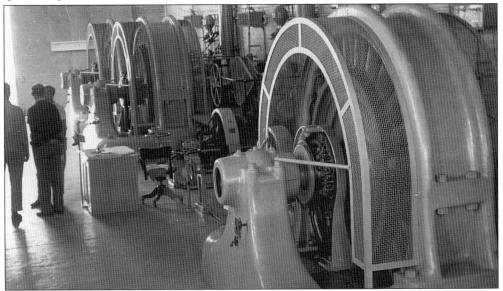

A YEAR BEFORE SHUTDOWN. This 1951 photograph shows the generators just one year before the permanent shutdown of the Folsom Powerhouse. The electrical output of each of the four generators was 750 kilowatts. Installed in 1895, they were reported to be the largest three-phase dynamos constructed up to that time. Each stood 8 to 8.5 feet high, weighed 57,877 pounds, and had a combined capacity of 3,000 kilowatts. Brought to California by ship around Cape Horn, these vintage generators are still in place today.

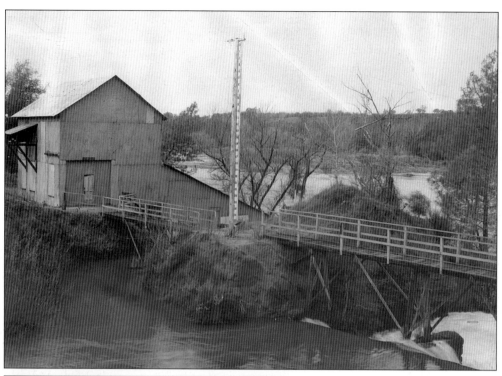

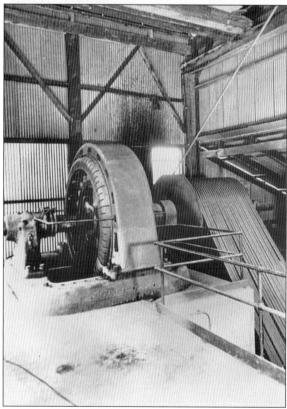

ROPE DRIVEN. Shown here during construction, this rope-driven plant and pedestrian bridge was built in 1897 between the main Folsom Powerhouse and American River to supplement electric output during times of low stream flow due to drought conditions.

ACHIEVING MAXIMUM EFFICIENCY. Using the 26-foot fall of water from the main powerhouse, the rope-driven plant produced an additional 750 kilowatts of electricity. To achieve maximum efficiency, the turbine assembly was set low to take advantage of the drop in the tailrace. The generator was set high above the turbine, safe from flood damage. Large ropes traveled between the turbine pulley and the generator, and an ingenious system of pulleys and counterweights controlled rope slack and stretch. Mechanical problems caused the unit to be retired in 1926.

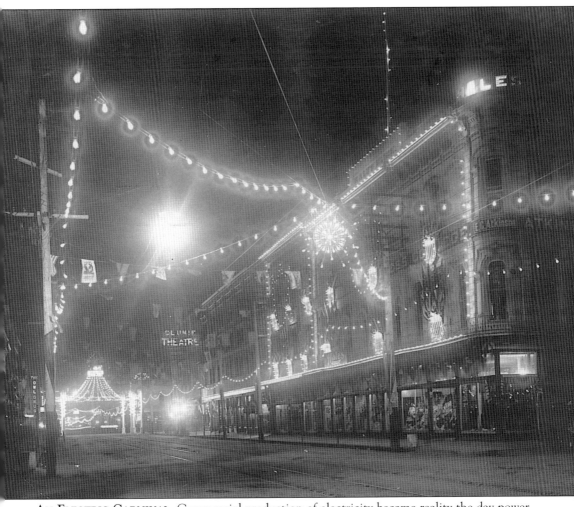

AN ELECTRIC CARNIVAL. Commercial production of electricity became reality the day power was sent 22 miles from the Folsom Powerhouse to a substation at Sixth and H Streets in Sacramento. Led by its two newspapers, *The Bee* and *The Union*, Sacramento couldn't pass up this great promotion opportunity. A Grand Electrical Carnival was held September 9, 1895, in conjunction with the California State Fair, "celebrating the 45th anniversary of the admission of California into statehood."

Downtown businesses and the state capitol were festooned with thousands of electric lights, and a giant parade of electric-powered floats dazzled the massive crowds that came from all over the state.

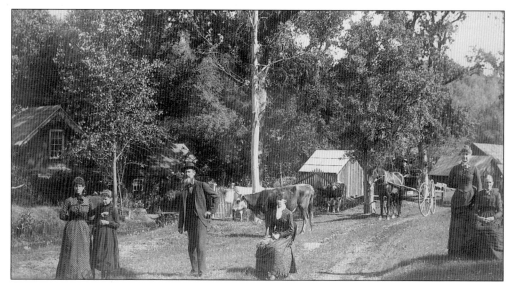

CROOKS FAMILY PIONEERS, C. 1889. The Crooks family poses in front of the family homestead. From left to right are Janet Crooks, Ida Walker (Janet's daughter), George Crooks, Eleanor Crooks Anderson, Ada Crooks, and Eleanor Person Crooks (George's wife). Charles Anderson Jr. is seated in the wagon. George Crooks came to Prairie City in 1853 to work for the Natoma Water and Mining Company. In 1855 he purchased ranch acreage and built a home next to the Natoma Ditch.

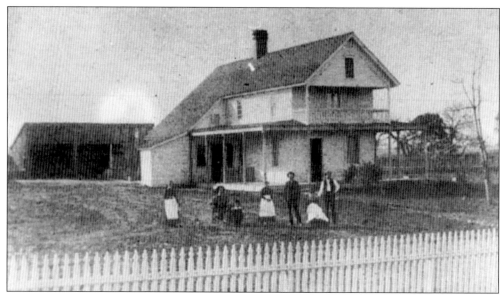

THE PERAZZO RANCH. Joseph and Alice Perazzo purchased this Folsom ranch from the J. Houston family in 1883, planning to graze cattle on the land. The Perazzos were the parents of Elvie Perazzo Briggs and her twin, Effie. Pictured among others who are unidentified are Alice and Joseph (far right) and Elizabeth "Lizzie" Houston (far left).

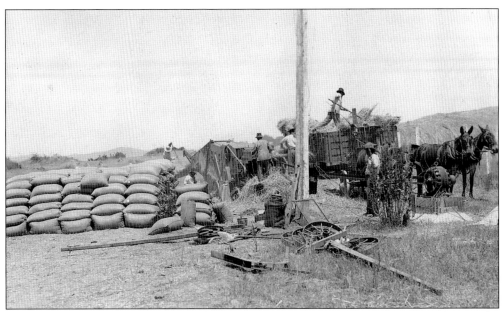

DAIRIES AND RANCHES. By 1846, before the discovery of gold, farmers began settling in the foothills east of Folsom. Strenuous labor occupied the long summer days of 1900 for the men pictured above, while their mule team, hitched to the wagon, stood waiting patiently in the sun.

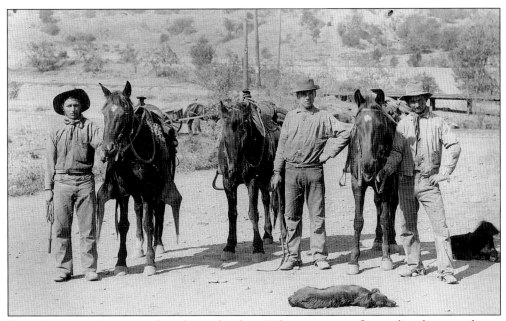

REAL COWBOYS. Dairies and cattle ranches kept Folsom's western flavor alive for more than a century. Many boys from town worked for the dairies during the summer. Harvey Tong, Will Johnson, and Roy Silberhorn (pictured from left to right) offer a glimpse into the life of a hard-working ranchhand in the early 1900s.

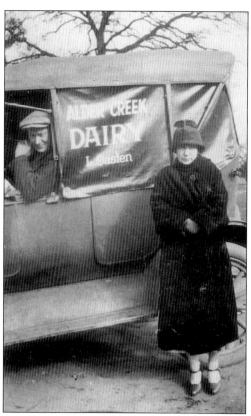

AFTER THE HORSE AND WAGON. A member of the Casten family poses in front of an Alder Creek Dairy delivery truck around 1919.

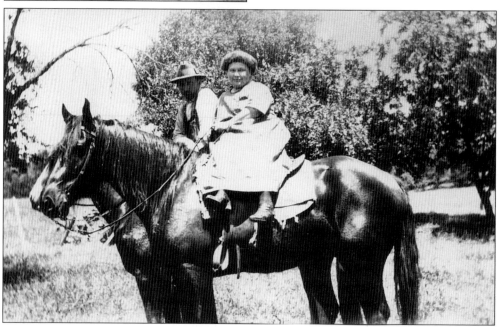

CHARLES AND FLORA MAY SILBERHORN, 1910. The Silberhorns, no strangers to the saddle, were often found on horseback at their Willow Spring Dairy. In this photo, Charles sits astride Buster and Flora May poses on Belle. Members of this family still reside in Folsom.

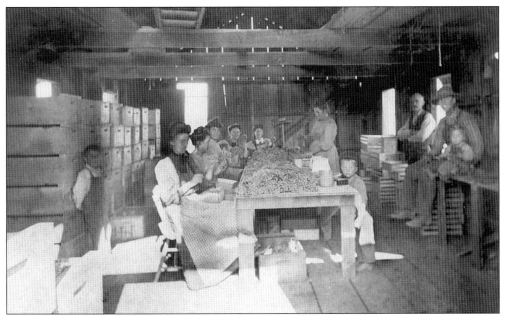

CULLING GRAPES, C. 1900. Women workers sitting to the left of the table culled spoiled grapes from each bunch with sharp shears, often nicking their fingers. Other women, like the one standing, then packed the grapes into crates; the boxes were transported to the railroad depot and then loaded on freight cars for nationwide shipment.

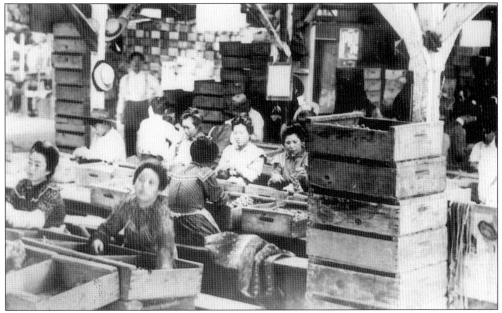

A DAY ON THE FARM. These workers contended with the weather, insects, and other annoyances, all in a day's work. Many times, the farmers made arrangements months in advance to sell their crops to distributors. The distributors would meet the farmers at the packing house to weigh the crops before shipping.

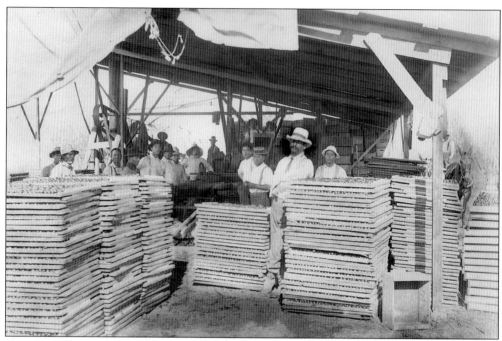

TAKING A BREAK, SUMMER OF 1908. Supervisors and Japanese laborers take a break from their work at the Pike and Kendall Prune drying yards in Folsom. After a boiling lye bath, the prunes were spread out on these wooden trays and left out to dry in the sun.

FLOUR MILL RUINS. Hazel McFarland, wearing the large hat, often took Sunday walks with her friends, ending up gathering Maidenhair fern along the American River Canyon. Other times, like this afternoon in 1905, they spent exploring favorite sites such as the ruins of the Stockton Flour Mill, an early California mill. The flour mill, destroyed in an 1862 flood and finished off by a fire in 1867, stood along the banks of the American River near the prison. Hazel's family owned the city's newspaper, *The Telegraph*, for 53 years. She served as its editor for many years, as well as the city's postmaster and first city clerk.

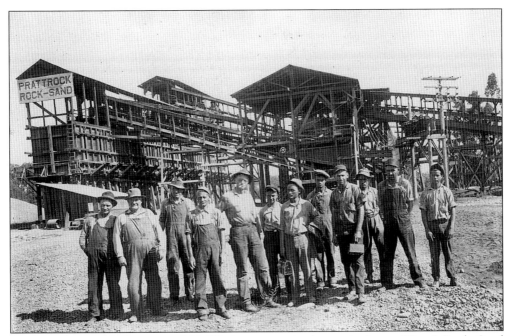

A ROCKY BUSINESS, AROUND 1920. Workers squint in the sun in front of Pratt's Rock, Sand & Gravel Company, located off lower Bidwell Street by Folsom Boulevard. Some opted to wear coveralls, but all were smart enough to don hats to keep the sun at bay.

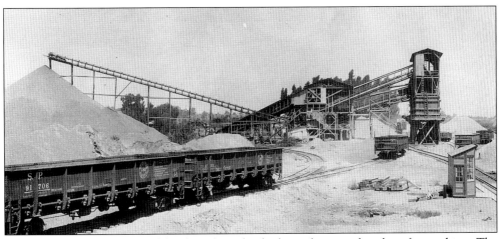

EMPTY ORE CARS. Ore cars like these brought dredge tailings to the plant for crushing. The town's children often used the cone-shaped piles, shown here behind the ore cars, like ski slopes. All they needed was a flat piece of tin large enough to sit on.

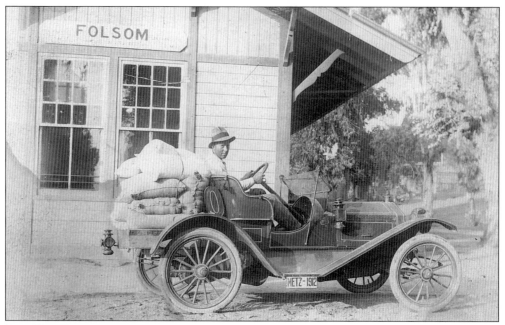

THE KIPP FAMILY BUSINESS, 1912. Gene Kipp, shown here in front of the Folsom train depot in his delivery truck, owned and operated Kipp and Higgins grocery and appliance store on Sutter Street for decades, beginning in 1909. Gene's son Jack went on to serve the city as councilman for many years, and as mayor for 16 years.

MARY BOWEN HALL. Mary, on the left, born in Sonoma County in 1933, was the founder and first president of the Folsom Historical Society. She is pictured here with "Folsom" Jim Philips. In the 1960s and early 1970s, Mary wrote a syndicated column, "Mother Lode Traveler," for *The Folsom Telegraph.* She also was the Folsom correspondent for the *Sacramento Union* and taught school in the local district. In 1989, she wrote the first of five "Emma Chizzit" mystery novels, which used Folsom as its backdrop. She died in 1994.

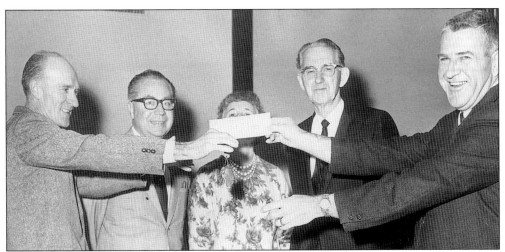

PUTTING THE MONEY WHERE HER MOUTH IS. Folsom dignitaries proved they had sense of humor in 1968 when they intentionally blocked City Clerk Artie Davies's face during a check presentation. From left to right are Sam McGuffin (Southern Pacific Water), Bob West (longtime Folsom Ford dealer), Artie, City Manager Cy Thomas, and Mayor Jack Kipp.

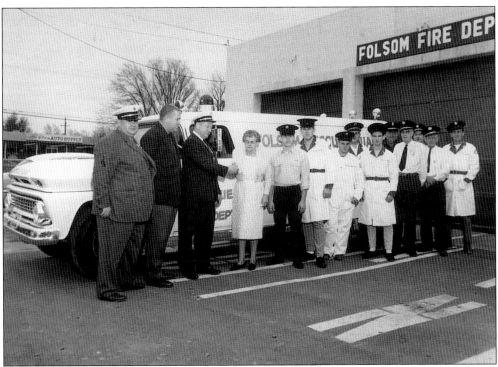

THE CITY'S FIRST RESCUE VEHICLE. In 1962, Folsom's Honorary Fire Chief Elvie Briggs donated this rescue vehicle to her hometown. On hand for the presentation were the following, from left to right: Jim Soukup, assistant fire chief; Jack Kipp, mayor of Folsom; Les Burnett, fire chief; Elvie Briggs; Ray Martin, Ron Hunter, and John Welsh, firemen; Bob Doucette, first aid instructor; Frank Surritt, fireman; Daryl Fahey, engineer; Ed Foster, captain of training; Dick Thurman, lieutenant; Ross Manseau, captain; and George McDermott, fireman.

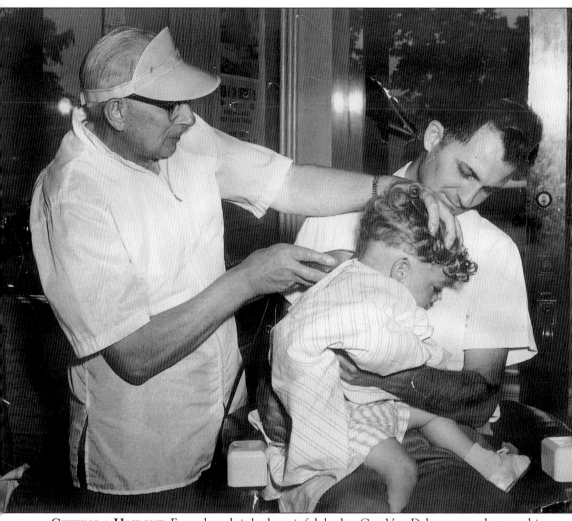

GETTING A HAIRCUT. Even though it looks painful, barber Guy Van Dyke managed to cut this little boy's hair without drawing any blood. The boy's father patiently holds his son, perhaps remembering his own first haircut.

Three
COMMUNITY LIFE

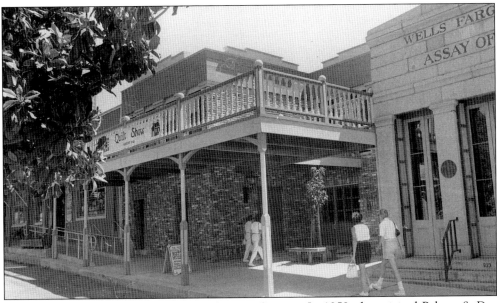

THE FOLSOM HISTORY MUSEUM, 823 SUTTER STREET. In 1959, the original Palmer & Day Assay Office, known as the Wells Fargo building, was dismantled to make way for a service station. Caring citizens banded together, forming the Folsom Historical Society in 1960. Funds were raised and all the savable parts of the old building were put in storage, where they were saved until the building was rebuilt. A later society project, spearheaded by Folsom residents Bee Hartzell and Mary Crisamore, resulted in the 1981 opening of the museum. Visitors enter the museum today through its two-story addition, built by the society in the late 1980s.

The Wells Fargo building wing is home to the museum's permanent exhibits. The new two-story addition sits on an adjoining piece of property, where Pony Express horses were once fed and watered from a natural spring that still flows in the back of the building. The museum houses a gift shop and space for changing exhibits, such as the Antique Quilt Show that has taken place annually in August since 1983.

Today, the Wells Fargo & Company Assay Office stands as a testament to Folsom's gold mining past; however, although the Wells Fargo name appears on its facade, that company never actually owned the building. Yale graduate Charles Theodore Hart Palmer built it in 1860. He was a banker, gold assayer, and buyer, as well as the express agent for Wells Fargo.

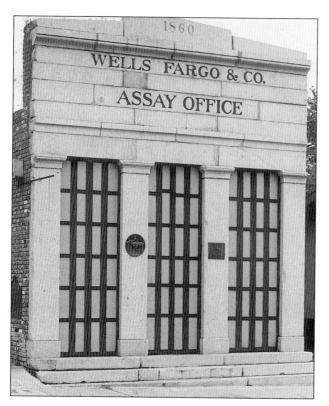

WELLS FARGO REBUILT. This is how visitors saw the Wells Fargo building from 1976 until the addition was finished in 1990.

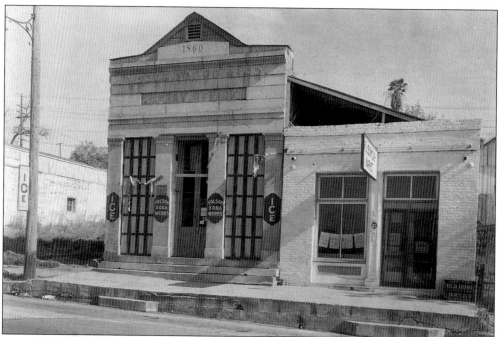

THE WELLS FARGO & COMPANY. This is the original structure built by Charles Palmer in 1860. Over the decades following its closure as an assay office, the granite building was home to a variety of businesses, including the Folsom Soda Works, pictured above.

50

A Chance Meeting with History. A simple twist of fate brought Folsom businessman and history devotee Herb Puffer face-to-face with a historic grave monument he had seen some 40 years earlier. The second time around, Puffer was instrumental in acquiring the marble grave marker of his hometown's founder, Joseph Libby Folsom, for the Folsom Historical Society.

In the early 1990s, Harkin Lucero retrieved the monument from the property of a Santa Clara chiropractic school. After cleaning it, Lucero deciphered the inscription and discovered that it was the gravestone that had been lost since the 1940s, when the graves in a pioneer San Francisco cemetery, Laurel Hill, were moved to Cypress Lawn in Coloma.

Puffer said he was offered the marker when no member of the Folsom family had come forth to claim it after the graves were moved. Because of the size of the heavy stone, Puffer was unable to transport it.

After Lucero made his announcement, the Folsom Historical Society asked Puffer to travel to Santa Clara and see if the stone was the one he had seen 40 years earlier.

Fund-raisers were organized to purchase the stone from Lucero and after $1,200 of the $3,300 needed was raised, Lucero decided to give the stone to the society. Today, the impressive monument sits in the museum's permanent display room.

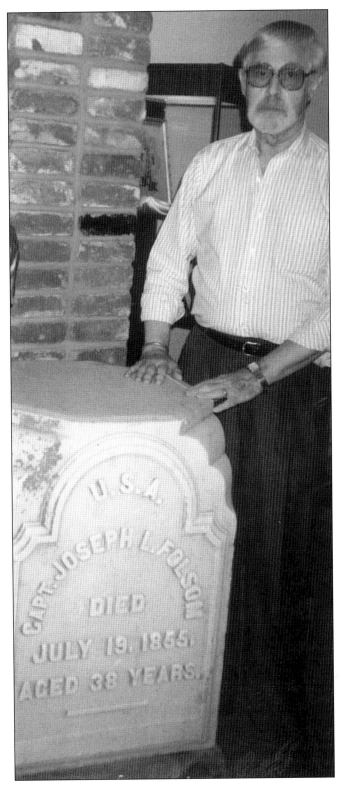

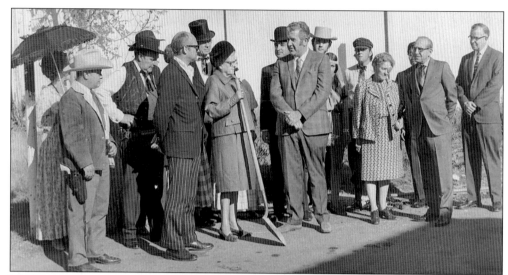

MUSEUM GROUNDBREAKING, 1974. John H. "Jack" Kipp (center) is surrounded by historical society dignitaries and other "characters" at the groundbreaking ceremony for the reconstruction of the Palmer & Day building.

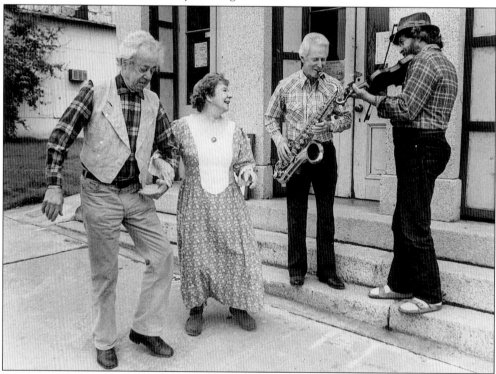

DANCIN' A JIG. Freddie Miller plays the saxophone with Bob Cound on fiddle, while Dan and Louise Welty dance in front of the Wells Fargo building. They were getting ready for the Mormon Island Christmas Ball in 1982. The Weltys were actors who produced and acted in melodramas at the Gaslighters Theater in the Sutter Club on Sutter Street. According to Dan, the only other theatrical entertainment in the town's history was in a building on the corner of Sutter and Wool Streets, now a parking lot.

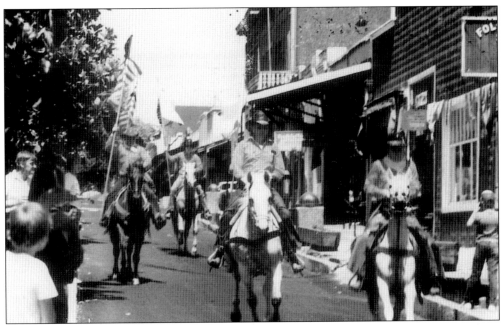

THE PONY EXPRESS RE-RIDE. The Folsom History Museum is the center of many Folsom events, including the Pony Express' annual re-ride, held in June. The rider on the right, Scott Newhaus, carries the mail into town like the young riders during the heyday of the Pony Express. Present-day riders re-ride the same route—1,966 miles from Saint Joseph, Missouri, to Sacramento, California—that the original riders followed during the company's short history from April 3, 1860, to October 24, 1861.

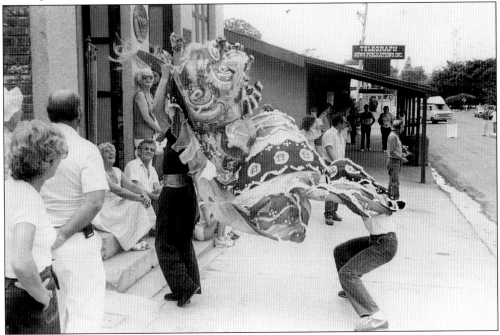

SACRAMENTO COUNTY HISTORY WEEK, 1983. The Chinese Lion Dance is performed in front of the Wells Fargo building by members of the Chung Mei Post No. 8358.

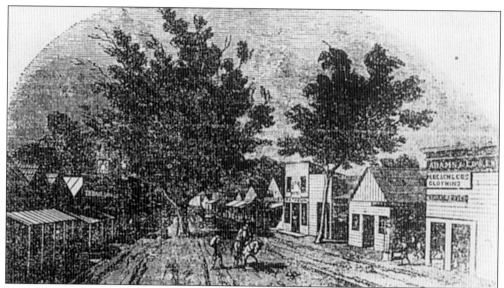

PRAIRIE CITY. This reproduction of a wood cut appeared in the book *Sacramento Pictorial Union* in 1854. An accompanying article from the book described Prairie City as occupying a plain between Placerville and Coloma Roads, 25 miles east of Sacramento. At the height of its prosperity, Prairie City boasted 15 stores, 10 boardinghouses, and a $50,000 quartz mill. Two stage lines operated daily, but the town eventually ceased to exist. Today, Intel sits near this site.

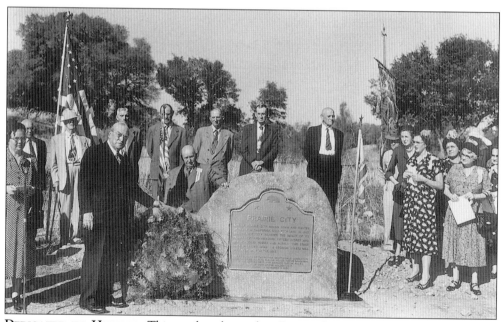

DEDICATED TO HISTORY. This marker, located at Prairie City Road and Highway 50, was dedicated in November 1950. Members of Granite Parlor No. 83 and Fern Parlor No. 123, Native Daughters of the Golden West, along with local history enthusiasts, were on hand that day. The ladies pictured are, from left to right, Francis Wagner, Hazel McFarland, Alice Coffey, unidentified, Pearl Bartz, and Eva Rogers. The others are unidentified.

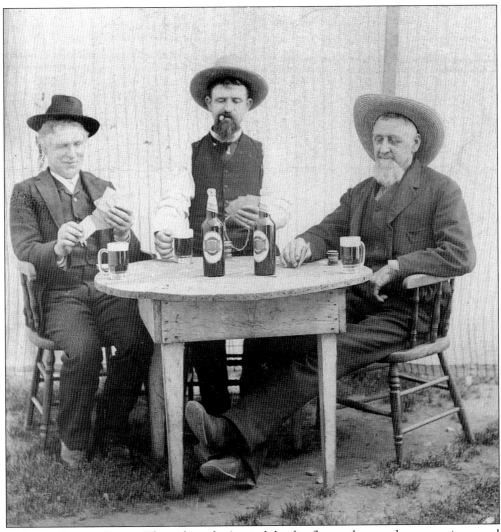

MORMON ISLAND GENTS. These three don't mind the dirt floor as long as they can enjoy a cool drink and a hand of poker. Mormon Island, one of more than 30 gold mining camps located in the area now covered by Folsom Lake, had a population of more than 2,500 by 1855. By 1880, the run was over and the town was all but gone, although ranchers and farmers populated the area until 1955.

Some of the families that made Mormon Island home in those early days included the Hoxsie family, who settled there around 1852. Marguerite Hoxsie, now deceased, was a Hoxsie great-granddaughter and a prominent Folsom resident.

Zollie and Louise Coffey moved to Mormon Island in 1920. Their daughter Artie married Bud Davies, and in 1937 they moved back to Mormon Island and purchased a ranch once owned by Harry Mette, who settled in the area around 1850. The Davies family operated a dairy there until 1950, when they moved to Folsom. Artie, now widowed, still lives in town in the house Bud built and moved two times: once from its original site off Green Valley Road to Mormon Island, and finally, to its present site on Natoma Street.

Richard "Red" and Lillian Dixon ran the 1,000-acre cattle ranch at Negro Hill, overlooking Mormon Island, that belonged to Red's grandmother. In 1954 they moved to Green Valley Road in Rescue.

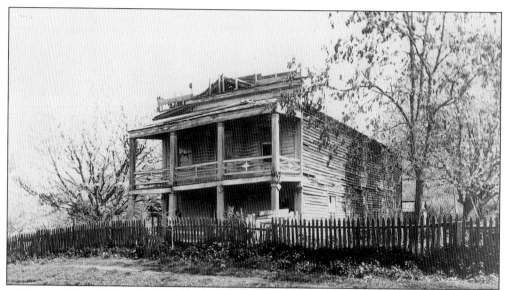

A BURIED PAST. This may have been the Picker building, located on Mormon Island, now under the waters of Folsom Lake. Other towns that once thrived in this area were known by these colorful names: Jenny Lind Flat, Negro Hill, Condemned Bar, Elephant Flat, Rattlesnake Bar, Red Bank, Maple Ridge, Poker Bar, and Salmon Falls.

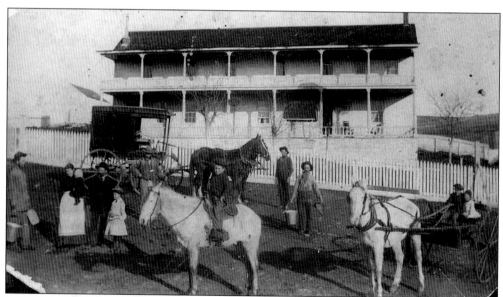

MORMON TAVERN, BUILT AROUND 1848. This large house was originally the Mormon Tavern, built near Clarksville, which is now El Dorado Hills. After Joseph Joerger immigrated from Alsace-Lorraine in 1856, he bought and operated the tavern for a time, later converting it to a home. Joerger's cattle and dairy ranching business would eventually cover most of the El Dorado Hills area, as well as 1,000 acres in Rancho Cordova. To the left stand Grandma and Grandpa Joerger, with children Ella and Gertrude; Josie is on the white horse and Willie and Roy sit in the cart. The other men present are hired hands.

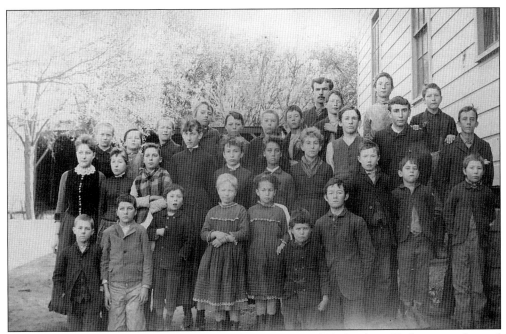

THE MORMON ISLAND SCHOOL, 1886. At the young age of 28, Sterling Clark was a judge and owner of the Union Hotel. After a long correspondence with his sweetheart, he traveled back east via the Isthmus of Panama to bring her to California and Mormon Island. During their return trip, he became ill and died in San Francisco. After his burial, Sterling's heartbroken widow, Rachel, continued on to Mormon Island, where its citizens gave her comfort and took her to their hearts. Rachel Clark repaid the kindness of her sympathetic neighbors by agreeing to teach their children. She began teaching classes in a tent on the Hoxsie Ranch in 1853.

LONG SINCE QUIET. This photograph of the Mormon Island School was taken in 1948 before Folsom Lake covered this area. The school was closed about 1938.

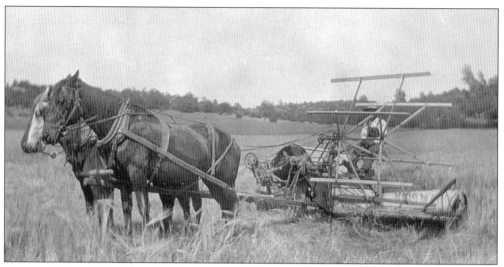

MOWING TIME. This photo of a farmer mowing hay may have been taken on Mormon Island, on or near the old Mette place. Only a few older folks can remember this style of mowing today.

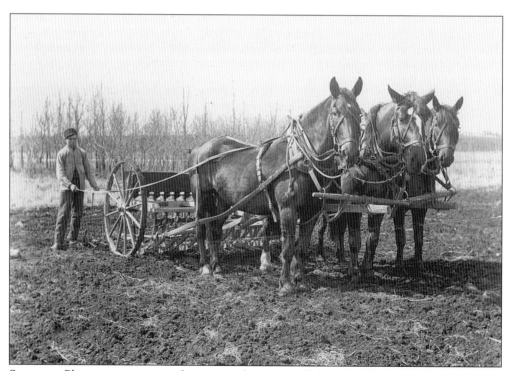

SEEDING. Planting time was a busy time for man and beast in the early days. Farming, however, has all but disappeared in the Folsom area, and most of the once-rich farming economy is just a memory.

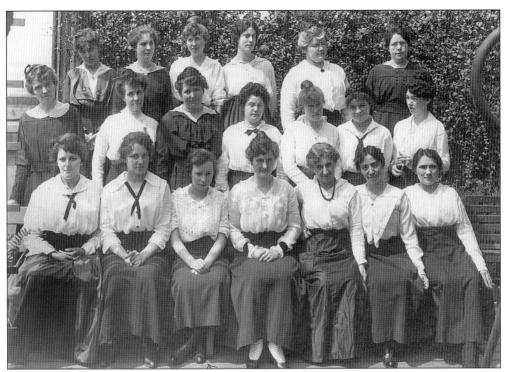

A DETERMINED LADY. Ella Ellis (front row, third from left) was born and raised on Mormon Island. After school and a short stint in San Francisco, Ella returned to keep books at Russi's Meat Market and then next door at Rumsey's Hardware, where she was lovingly called "Sarge." When the federal government began buying land on which to build Folsom Dam, they didn't bargain on how tough Ella could be. Not satisfied with what they offered her for her Mormon Island property, she fought them until they gave her the price she wanted. Along with Julie and Bob Bowen, she founded the Ellis & Bowen Insurance Agency in the 1940s.

THE RED BANK WINERY. This view shows the wine cellar of the Red Bank Winery at Mormon Island. The building was badly decayed, so owner Bud Davies tore it down around 1945. He later placed the winery's sign on one of his buildings at the corner of Sutter and Wool Streets, where it still hangs.

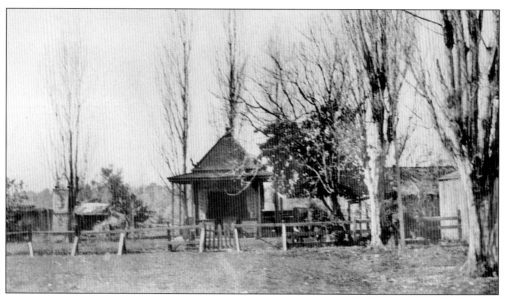

THE CHINESE JOSS HOUSE. The Chinese Joss House, dating from the late 1800s, stood in an area known as Folsom's Chinatown, between Leidesdorff Street and the American River, below the powerhouse. Three Chinese cemeteries dotted the river bluffs. By the late 1880s, the Chinese population in and around Folsom had swelled to more than 3,000. Lured by gold, thousands of Chinese immigrants filled the mining camps throughout the region. Some of them were employed by the mining companies, but more often they formed their own outfits and worked claims the white miners considered "played out" or not worth the effort. Because of their patience, they were often successful, but by 1900, less than 100 Chinese remained.

When the gold began to run out, many of these hard-working miners stayed on to work as small businessmen, farmers, laundrymen, cooks, fishermen, and storekeepers. They were on the work crews of such history-making tasks as the building of the transcontinental railroad and the first Delta levees.

Chan Oak, who came to the area during the gold rush as a teenager, worked as a miner, earning $3 per month, plus room and board. Later, he became chief translator, labor agent, banker, scribe, and all-around liaison between the Chinese and Caucasian communities. Some of his descendents still call Folsom home.

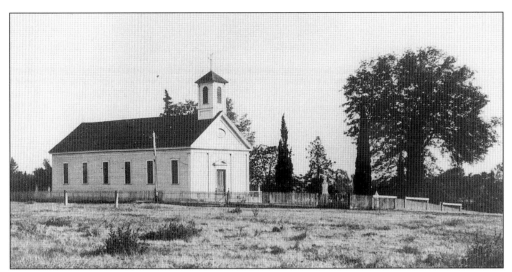

FOLSOM'S OLDEST CHURCH. Although Father Ingoldsby conducted services in Negro Bar or Folsom beginning in 1851, the city's first church would not be built for six more years. In 1857, Father Quinn and his parishioners built St. John the Baptist Catholic Church at Sibley and Natoma Streets. The oldest building in town, it stands today as a testament to simpler times.

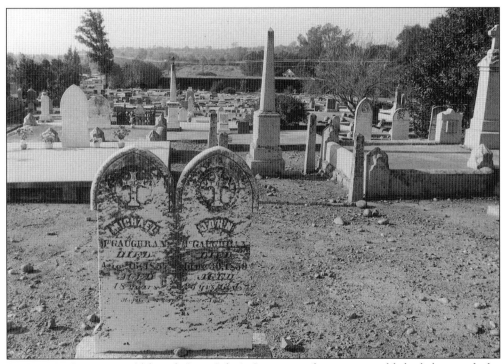

ST. JOHN'S CEMETERY. Although Saint John's Cemetery, above, was established along with the church in 1857, Lakeside Memorial Cemetery, one block west off Forrest Street, started in 1846. It encompasses Negro Bar Cemetery, later known as Citizen's Cemetery, Jewish, Odd Fellows, Masonic, Cook's/American Legion, and New Masonic cemeteries. Only one early grave stone remains, dated October 29, 1850, for a victim of the great cholera epidemic.

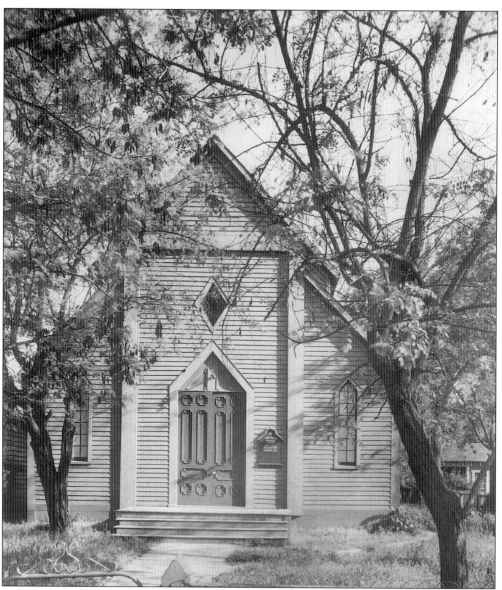

THE TRINITY EPISCOPAL CHURCH. Trinity's congregation organized in 1856, gathering at the Hook & Ladder Company Hall at Sutter and Wool Streets until they raised $4,000 to build their own church in 1860. The new church, Folsom's second oldest, was built on Figueroa Street, near Wool, where it still conducts services.

The church's old registers serve as a history of the times. From 1855 to 1865, the register recorded many events, such as births, marriages, deaths, and church activities. The register's "cause of death" column records some very traumatic events, such as "Consumption, Putrid Sore Throat, Trodden by Horse, Pistol Ball," and others.

As mining activity slowed during the 1870s, the church register reflected the loss of population, even closing from 1880 to 1895 and again from 1930 to 1942. In 1942 it reopened for regular services.

In 1984, a mortgage on the building allowed parishioners to make structural renovations while maintaining its historic appearance.

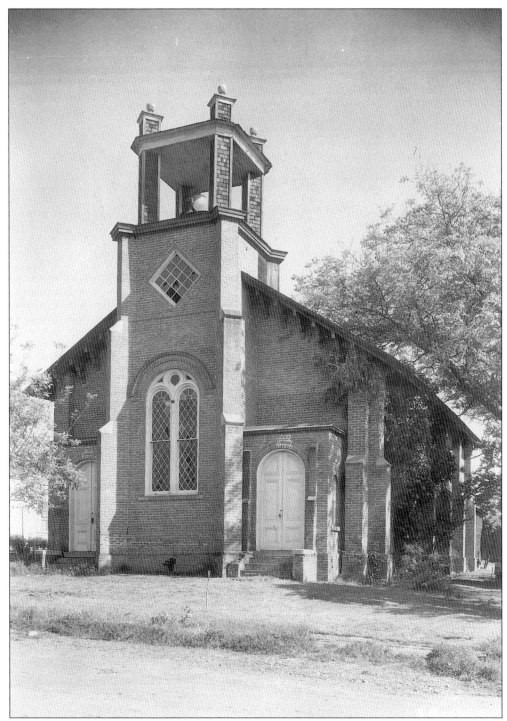

THE LANDMARK BAPTIST CHURCH. Located on Figueroa Street between Scott and Riley Streets, this church was originally established as a Methodist church in 1860. In later years it became a house of worship for Presbyterians. In addition, Landmark Baptist once housed the high school until a school building was erected.

THE HOLY CROWN PICNIC. This picnic to outdo all others took place in Natoma Grove, south of Bidwell Street on Sibley. From 1905, the picnic drew thousands from Sacramento and "down river," who traveled to Folsom by train to attend the event. Originally, the occasion was a fund-raiser for St. John's, organized by members of the Portuguese community.

PICNIC FUN, 1905. Were these picnic-goers lined up on the starting mark for a race, or were they just posing for the photograph? The gentleman in the middle may be holding a starting pistol. Note that one or two of these participants are not wearing hats.

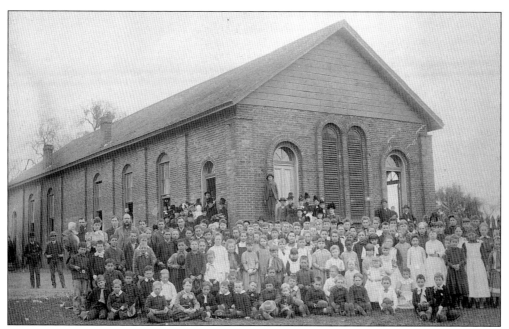

THE FOLSOM GRAMMAR SCHOOL. This charming photograph, taken about 1912, shows the entire student body of the Folsom Grammar School, which was located on Mormon Street where Granite School now stands. In those days, starched collars on boys and girls and short haircuts for boys were the norm.

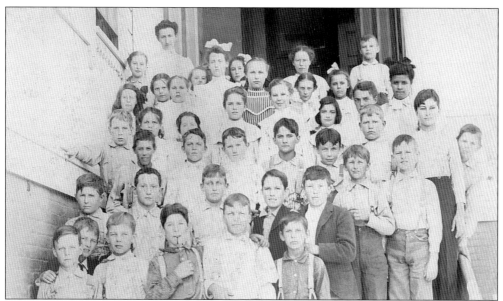

ANOTHER SCHOOL. This was the student body of a school that once stood in the Negro Hill district, which was located in an area near Folsom now covered by the southwestern portion of Folsom Lake. Like several other by-gone communities and geographical areas, the name "Negro Hill" can only be found today in historical documents.

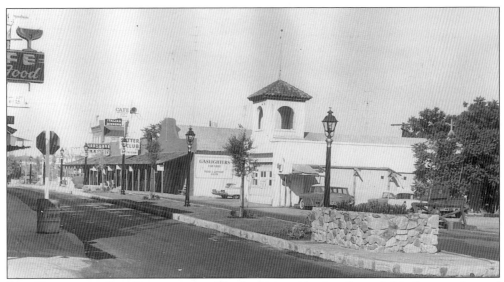

THE VOLUNTEER FIRE DEPARTMENT. The building with the tile-roofed bell tower, located near the corner of Sutter and Riley Streets, was once the home of the Folsom Fire Department. Guiseppe Murer, who at one time served as volunteer fire chief, built it to reflect his Italian architectural heritage.

A VISION IN RED. W.E. VanWinkle, fire chief from 1928 to 1942, and Kenneth Ellis give one of the department's fire trucks a bath. Major fires in 1866, 1867, 1871, and 1886 damaged Folsom's business district. In 1889, the Natoma Company built a system of water mains and fireplugs along Sutter and Wool Streets, ending the era of major fires.

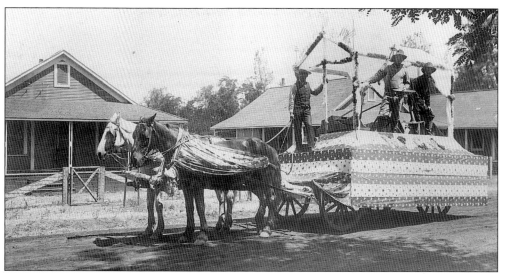

AN INDEPENDENCE DAY PARADE. All the world loves a parade and Folsom was no exception. Parades were a highlight of the year, and this simple float, photographed on Natoma Street on the Fourth of July, around 1910, was patriotic, if nothing else. James Logue is the man in the middle. His father-in-law was a blacksmith on Scott and Persifer Streets, next to Miller's Funeral Home.

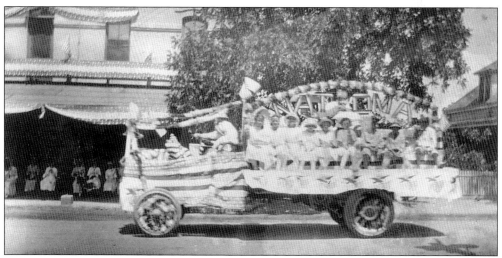

RIDING THE FLOAT. The Fourth of July parade has probably been a tradition since the Declaration of Independence was signed. Parade entries represented all segments of a community, and in this 1913 parade, a Natoma Company float was overflowing with people, probably employees. In the background is the Enterprise Hotel, in operation by 1889.

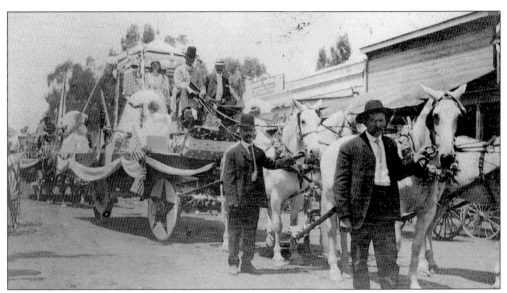

THE FOURTH OF JULY PARADE, 1900. Filled with pageantry, tradition, and pride, parades were a part of a self-reliant, community-based culture at the turn of the century. Folsom residents closed their businesses, decorated their homes, and planned parties and picnics; they dressed in their finest, set off firecrackers, and danced the night away. Here, two caballeros proudly parade their horses.

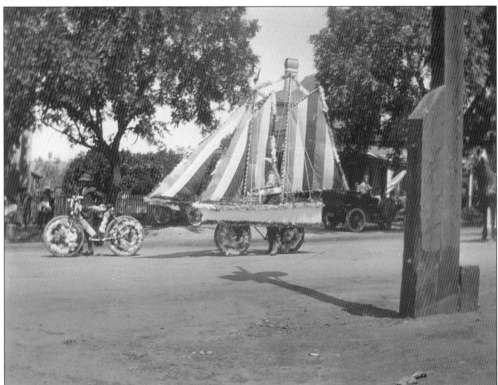

BOAT ON A BIKE. Upon closer inspection, one can see that this sailboat float is balanced on a bicycle and a man is inside the "boat." The picture was taken July 4, 1913.

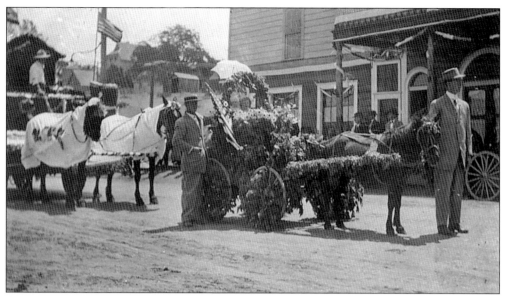

A FANCIFUL FLOAT. Colorful costumes, flower-laden coaches, and decorated horses fill this photograph.

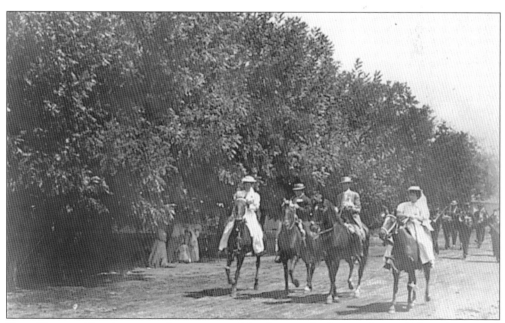

FINE HORSES. Parades are perfect opportunities for proud riders to show off their horses and latest riding finery. These four do so with style in 1907.

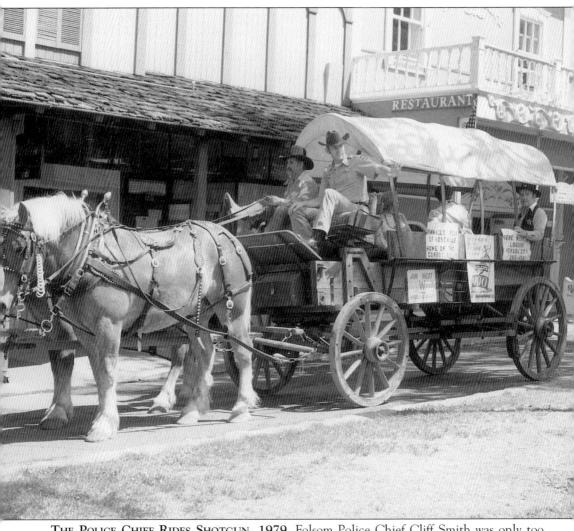

The Police Chief Rides Shotgun, 1979. Folsom Police Chief Cliff Smith was only too happy to ride shotgun position on this horse-drawn wagon during a parade along Sutter Street.

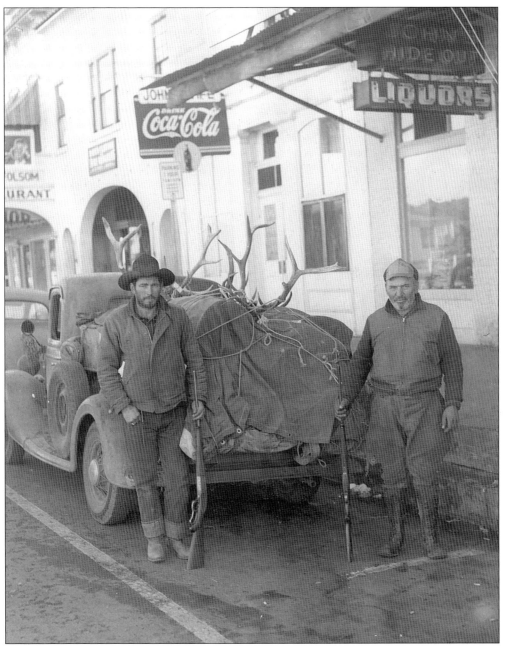

TROPHIES OF THE HUNT. Home from the hunt, Buck McKiernan and John Brazil pose in front of John's bar, located on the 700 block of Sutter Street, in the 1930s. Hunting was popular in those days, a tradition that many men grew up with, which not only put meat on the table, but also earned bragging rights for the hunter.

THE OLD WEST LIVES ON. The Folsom Championship Rodeo has been drawing huge crowds to Dan Russell Arena since 1962. Every year, the event takes place over a four-day period that includes the Fourth of July. From bronc busting to bull riding, the event offers thrills for everyone. The Russell family has been a part of Folsom history since Daniel A. Russell came here from Illinois at the close of the Civil War to raise horses and cattle.

COUNTING DOWN. Folsom Jim Phillips and Bud Davies ham it up while they wait for the final vote to be counted in the contest for the mythical office of Mayor of Sutter Street. This tenth anniversary celebration of the Sutter Street Mall took place in 1974. "Folsom Jim" lives in Roseville. Bud passed away in 1983.

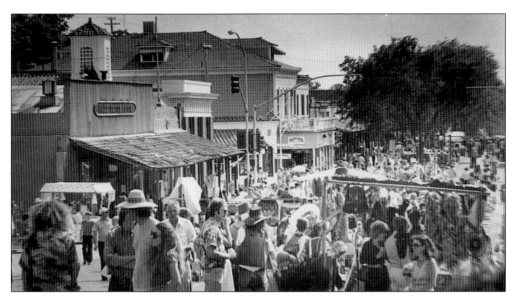

SUTTER STREET, HUB OF ACTIVITY. Several annual Sutter Street events bring visitors from miles around to our town for a day of shopping, food, fun, and entertainment. This photograph shows Sutter Street during the annual craft fair. The tallest building in the center is the Folsom Hotel.

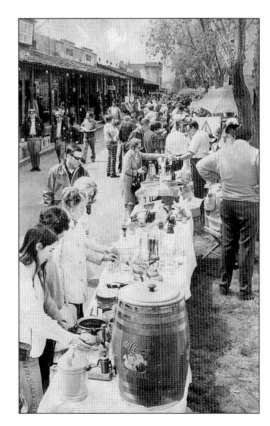

STEP RIGHT UP. Visitors check out some interesting finds during the Sutter Street's annual antique fair. The show and sale has been one of the most popular events in town for more than 25 years.

THE FOLSOM ZOO. In the late 1950s, Gordon Brong, superintendent of parks for the City of Folsom, was given a crippled deer to care for until it had recovered. The deer became Gordon's first animal project, but certainly not his last. By 1963, he had taken other injured or lame animals, including a badly burned California Black Bear cub. That same year, the Folsom Zoo opened in Folsom City Park. Gordon retired in 1981.

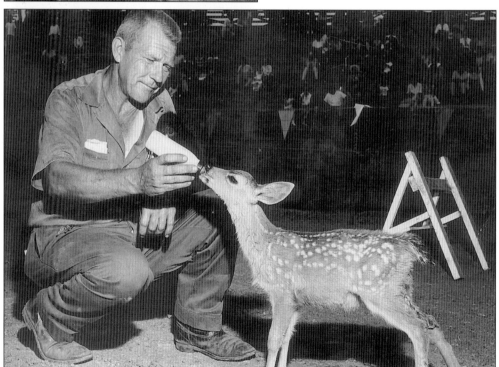

FRIEND OF THE ANIMALS. Gordon Brong never tired of ministering to his injured, orphaned, or outcast animal tenants at the zoo. And, while the unique zoo eventually earned the nickname, "The Misfit Zoo," Gordon never felt his animals were misfits; he knew they fit right in.

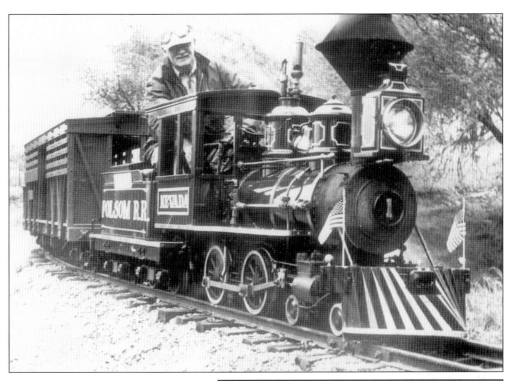

THE LITTLE TRAIN THAT COULD.
The "Nevada" has been carrying
delighted children and their parents
along its 2,600 feet of track in
Folsom City Park since 1970. The
miniature coal-burning train is a
replica of the 440 Diamond Stack,
the first engine to pull the first
passenger train of the Sacramento
Valley Railroad to Folsom in 1854.
George and Louis Sherman brought
the train from Tilden Park in
Berkeley, California.

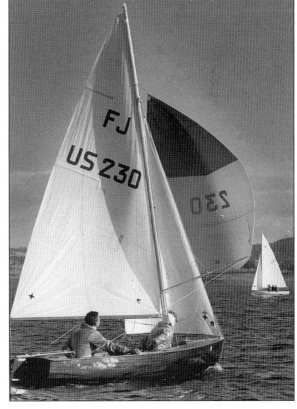

FUN ON THE LAKE. Members of the
Folsom Lake Yacht Club take
advantage of a breezy day on the
lake, which is located about one
mile northeast of Folsom. The
Folsom Lake Recreation Area,
which includes both Folsom Lake
and Lake Natoma, encompasses
17,500 acres.

THE FOLSOM LAKE MARINA BEFORE THE MOVE TO BROWN'S RAVINE. Year-round boating, fishing, camping, hiking, horseback riding, bird watching, and just plain relaxing are some of the things that make this lake popular.

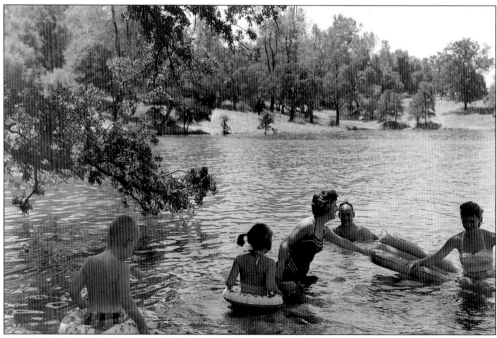

THE WATER'S FINE. Families have been enjoying summers on Folsom Lake since its dedication in 1956. The man-made lake covers what were once the towns of Mormon Island and Salmon Falls. Just a few miles upstream from Folsom, the north and south forks of the American River merge into Folsom Lake.

Four

FAMILY LIFE

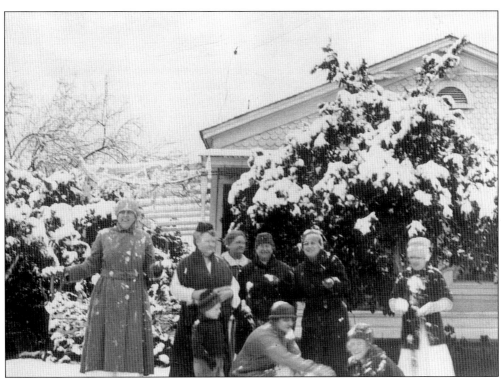

SNOW IN FOLSOM. Snow in the valley is a rare thing, but it did snow on this day in Folsom sometime in the 1920s. The group of friends look like they are thoroughly enjoying the making of snowballs. Could a couple of them be "wearing" a snowball or two on their coats? From the mischievous looks on a few faces, we'd say so. They are pictured as follows, from left to right: (front) Leland Miller, Alma Hansen, and Kate Clemens; (back) Mamie Daecking, Hattie Miller, Minnie Showers, Emma Eveland, Lottie Levy, and Fanny Dickson. Note the fish scale shingles on the house.

Form PS 300 Account No. 44

Depository Office Folsom C...

Luke Pantages
(Name of depositor)

hereby make application to open a postal-savings accoun
subject to the rules and regulations prescribed by t
Postmaster General, and further state that I have
other postal-savings account.

Witness my hand this 10 day of Dec, 1912

Luke Pantages
(Depositor's signature)

If the depositor signs by mark, the signature must be attested by wit

Witness (Signature)

Address

Occupation

Residence

Occupation Dredge man

Birthplace Italy

Age 45 Date of birth 1867 Jan
(Year) (Month)

Race or Color, White

Father's name John Pantages

Mother's Christian or given name Ecatr...

(If a woman, state whether married, single, or a widow

Form PS 300 Accou...

Depository Office Folsom C...

I, *Henry E. Fre...*
(Name of depositor)

hereby make application to open a postal
subject to the rules and regulations p...
Postmaster General, and further state
other postal-savings account.

Witness my hand this 20 day of ...

+ *Henry E. Free...*
(Depositor's signature)

(If the depositor signs by mark, the signature must be

Witness (Signature)

Address

Occupation

Residence Folsom C...

Occupation Soldier

Birthplace Bristol Engla...

Age 63 Date of birth 183...
(Year) (M...

Race or Color White

Father's name Wm Free...

Mother's Christian or given name Sara...

(If a woman, state whether married, single, o...

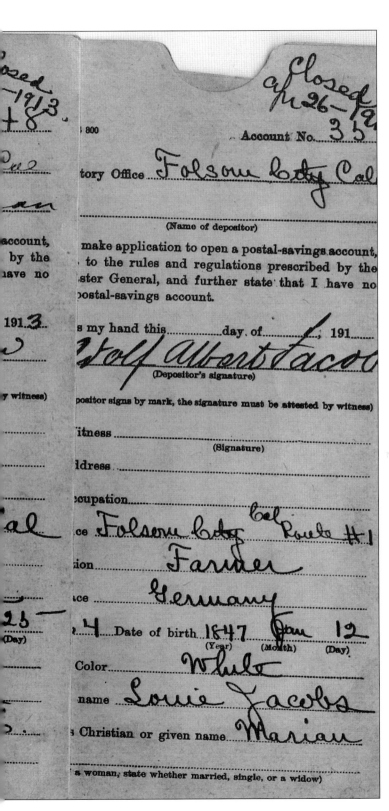

SAVING FOR A RAINY DAY. Many folks saved their hard-earned money with the U.S. Postal Service. These envelopes, which held the customer's deposit slips and included a record of activity on the back, reflect the diversity of the people living in Folsom, as well as the range of occupations from which they earned their living.

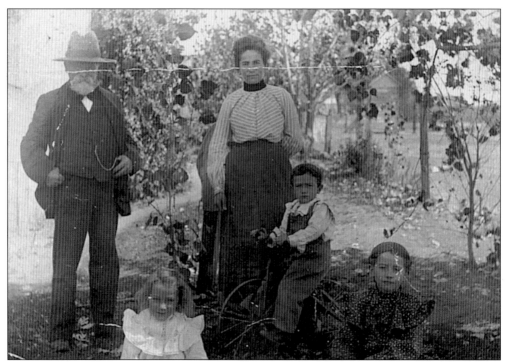

THREE GENERATIONS. This photograph, taken around 1903, shows three generations of the prominent Joerger family: Joseph Joerger, his daughter, Frances Joerger Miller, and her three children. Frances's husband, Emil Miller, was the son of Jacob Miller, founder of the Miller Funeral Home.

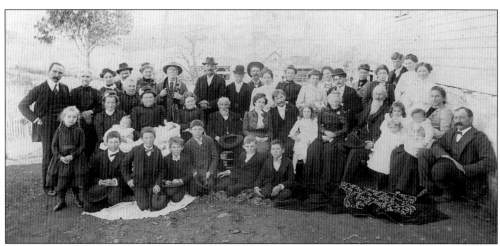

BLENDING TWO FAMILIES. Although it was not the custom to smile for photographs in 1901, this group portrait was taken at the Joerger Ranch on the happy occasion of the marriage of Ella Joerger and William Waddel.

THE COHN HOUSE, 1890. At this time, the original Simon Cohn summer home was just a start to the Queen Anne Victorian home that Simon's son-in-law, Phillip Cohn (no relation), finished. The house was located at 305 Scott Street. The part that Simon, a Polish immigrant, built in the mid-1860s is the present-day kitchen.

THE BURNHAM HOUSE. Nan Burnham stands on the porch of her home, built around 1891 at 602 Figueroa Street. The man on the lawn to her left may be her husband, James Henry Burnham, a Folsom druggist, Wells Fargo agent, and insurance agent. This home, with its attractive cupola, is an outstanding example of Victorian architecture. In 1975, an electrical fire destroyed the cupola.

PETS HAD THEIR DAY. This is a pampered dog owned by the Burnham family. Notice the kerchief around his neck. Had he been to an early-day dog groomer? Were there pet groomers in those days?

A View of the Burnham House.
James Burnham came to Folsom in 1855 as a ten year old. While still a child, James and his family moved back to their home state of Texas, but by 1868, when James's own son was born, he was back in Folsom.

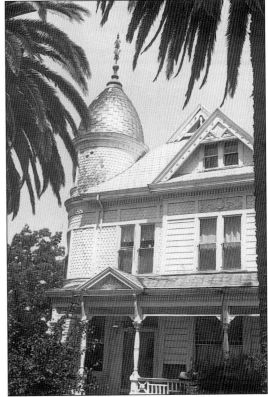

Another Look at the Cohn House.
This area of Folsom was called "Nob Hill" because of the fine homes that graced its streets. In 1981, the Cohn House was listed on the National Register of Historic Places. This photograph, taken around 1890, shows the Cohn family, including two tots in a baby carriage.

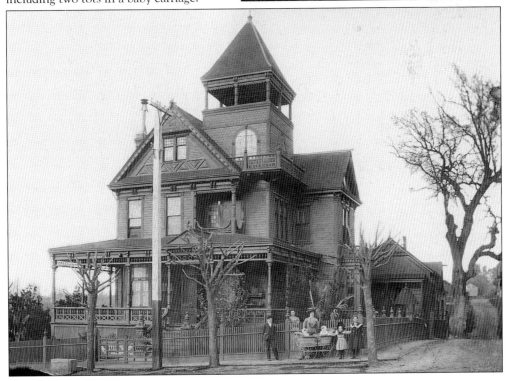

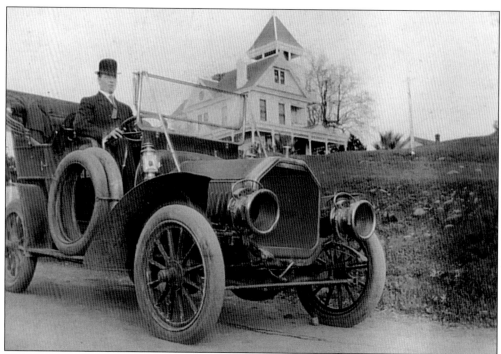

A Dapper Man and His Automobile. This gentleman sits proudly at the wheel of his 1902 Franklin. The Cohn House is visible in the background.

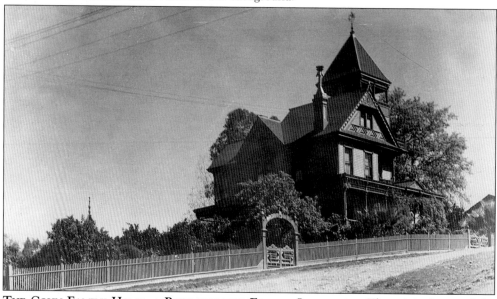

The Cohn Family Home, a Recognizable Folsom Landmark. The original part of the home dates back to the 1860s when Simon Cohn and his family lived in it. At Simon's own general store on Sutter Street, his daughter fell in love with Phillip Cohn, a drummer who frequented the store. Phillip married Alice, began a business partnership with his father-in-law, and designed the Cohn House as it appears today. At one time in Folsom's history, the Cohn House was the "place to be seen." Glenn and Sharon Fait have been restoring the home since they purchased it in 1966.

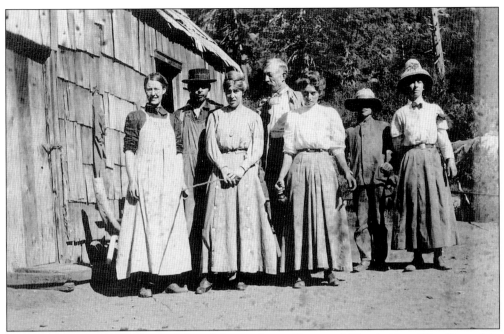

THE SUMMER OF 1911. Pictured from left to right are Einia and Claude Hart, Rita Goan, Mr. Walch, Ina Morrison, and Ernest and Addie Hoxsie. Four generations of Hoxsie's lived on Mormon Island.

THE SUMMER OF 1963. Folsom residents get together on balmy, summer days. From left to right are as follows: (front row) Mr. and Mrs. Wolff (Wilma Hoxsie's parents) and Ernie Metz; (back row) Mrs. Metz, Wilma Hoxsie, and an unidentified person.

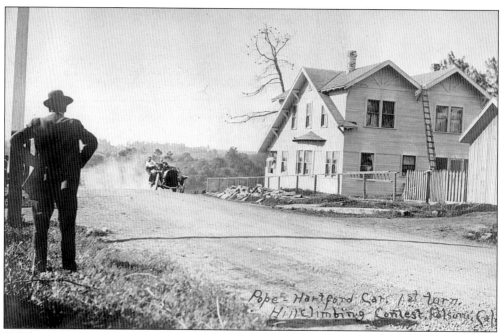

Pope-Hartford Cars 1st Turn. Hill Climbing Contest. Folsom, Cal

IS THAT THE WINNER? In 1910, a bystander watches the Pope-Hartford car stir up a cloud of dust as it takes the first turn next to the Bean House at Folsom's first hill climbing contest, which is now just a faded memory.

STANDING PROUD. This young man looks proud of his pony and carriage. We can't begin to understand what it was like to travel on unpaved roads, often just rutted trails, but this boy was proud of his up-to-the-minute conveyance.

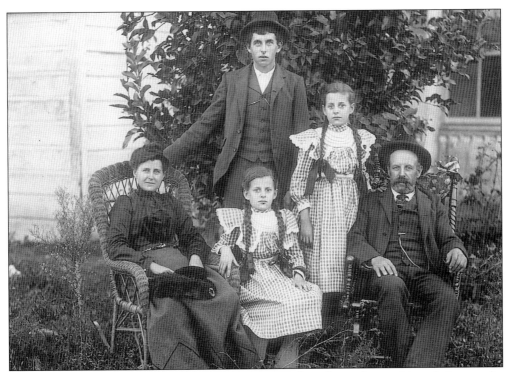

THE PERRAZOS. Alice Perazzo Wild Anderson, seated in the wicker rocking chair, was the mother of Elvie Briggs, one of the twins pictured here. The other twin was Effie. Elvie was mother of Mercedes Relvas. The Perazzos, who ranched and operated a dairy off what is now Blue Ravine Road, owned a great deal of land that was dredged by the Natomas Company.

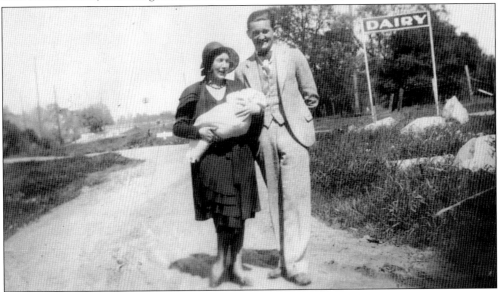

PROUD PARENTS. This couple, who may be Lawrence Casten with his wife and young baby, stands at the front of the Casten family dairy, once located around the area where Highway 50 and Folsom Boulevard meet. Lawrence and Elsie Casten started the dairy in 1918. After Lawrence's death in 1936, their sons, William and Richard, ran the dairy.

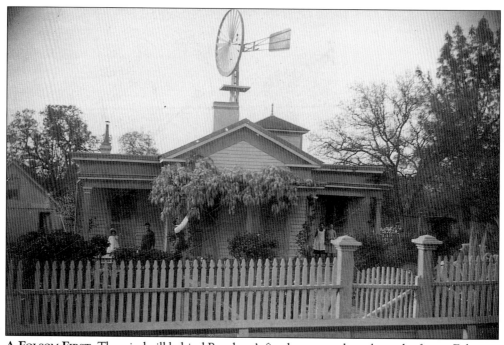

A FOLSOM FIRST. The windmill behind Burnham's first home may have been the first in Folsom.

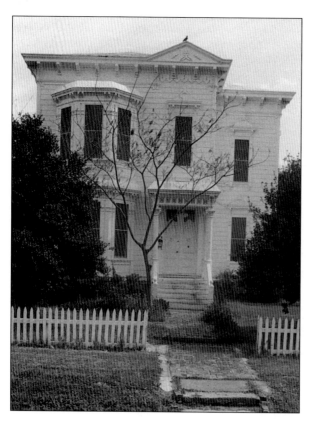

THE JACOB HYMAN HOME. This structure, believed to have been built at the corner of Figueroa and Scott Streets before 1889, is a fine example of the Classic Revival style. As befitted its fancy facade, the home was a social center for Folsom notables of the day. Hyman, once one of Folsom's leading citizens, was a drygoods merchant and also the builder of the Hyman Building on Sutter Street.

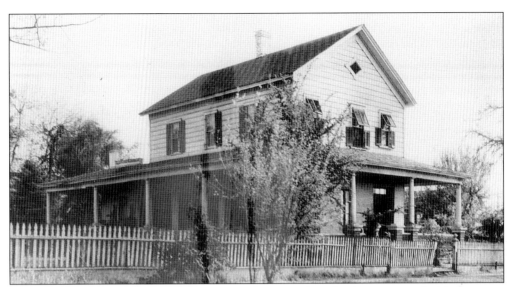

ALL FENCED IN. The Baileys, who operated it as a boardinghouse, owned this home at one time.

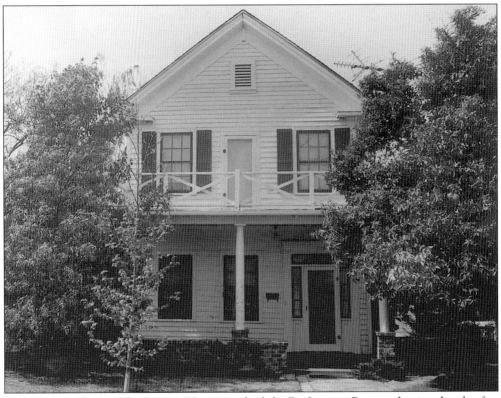

THE RUMSEY HOME. The Rumsey House was built by Dr. Lerman Bates, a dentist, shortly after the founding of Folsom in 1856. The milled lumber and siding for this home, which may be Folsom's oldest, was shipped around the Horn from the state of Maine. In 1925, Bill Rumsey, owner of Rumsey Hardware, bought the house during the Bates's estate sale. In turn, Bill's daughter-in-law sold it following the death of her husband, Clem Rumsey.

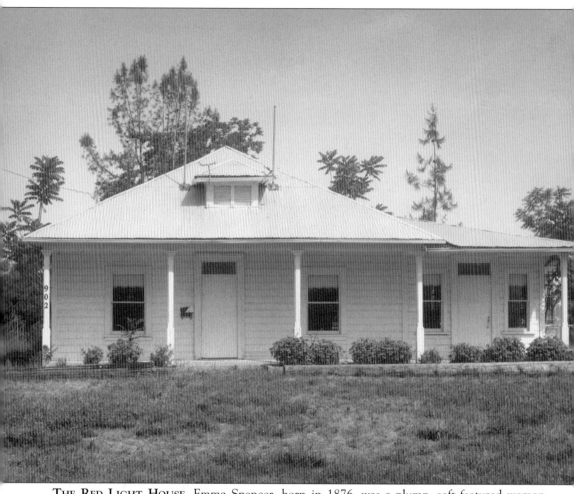

THE RED LIGHT HOUSE. Emma Spencer, born in 1876, was a plump, soft-featured woman whose looks belied the independence and resourcefulness of her personality. After the 1925 death of her second husband, Clark Spencer, the 49-year-old widow established a house of prostitution, which became known simply as Emma's Place, after its madam.

Her business card, which is displayed in the Folsom History Museum, says, "Alpine Rooms, Folsom Cal., Mrs. Emma Spencer, Proprietor. Rooms for Rent by the Day, Week or Month." In its heyday, her bordello, which employed a few "girls," was reportedly lavishly furnished with plush, red velvet draperies, thick carpets, and fine furniture.

Emma loved books and, because of foot problems, spent most of her time at home, running the business, raising chickens, and reading. Her personal treasures included a 10-volume collection of American and British poetry by Edwin Markham.

During World War II, Emma's Place continued to operate, but the bordello was shut down permanently by the Sacramento County Sheriff's office in the 1950s.

Emma lived out her final years as a penniless patient in what was then the Sacramento County Hospital. When she died, she was buried in a plot donated by a Folsom resident so she would not have to be buried in a pauper's grave.

Since its early years, the building has been home to a beer hall, an art gallery, a Montessori school, and a school of dance. In 1993, June Hose, ex-manager of the Folsom History Museum, acquired the white frame house that once stood at 902 River Way. Today, it sits on blocks, awaiting its rebirth as a classroom for the City of Folsom's Parks and Recreation Department.

Five

GETTING AROUND FOLSOM

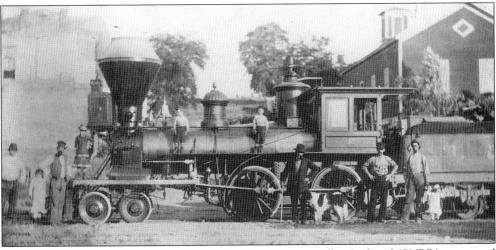

CALIFORNIA'S FIRST RAILROAD. The 22-mile Sacramento Valley Railroad (SVRR), organized by Charles Lincoln Wilson in 1852 and designed by Theodore Judah, was the first railroad in California. Posing here *c.* 1882 are, from left to right, unidentified, Cora O'dell, William H. Nichols, Lena Nichols, Charlie Nichols, Will Nichols (killed in the Boxer Rebellion), Andrew Wagner (train engineer), Bummer the dog, two unidentified men, and Maude Nichols. The old Fireman's Hall, which was torn down around 1910, is visible in the background to the right.

Regular operation of the SVRR began February 3, 1856, linking Folsom with Sacramento and on to San Francisco. At one time, it was boasted that 21 stage lines and 30 freight wagons awaited the trains daily. By 1861, 1,500 men were employed at the extensive machine shops that had been built at the Folsom terminus. In 1869, the operation was transferred to Sacramento, and in 1878, the Folsom shops closed down due to sporadic use.

In 1898, when the Southern Pacific assumed ownership and it became the oldest link in SP's western line. In January 1939, passenger service to Folsom ended, and by mid-1971, SP had discontinued all commercial service to Folsom.

Railroad buffs know that in 1856 the SVRR built the first turntable in the west, right here in Folsom. Today, efforts are underway to restore the turntable to its former appearance.

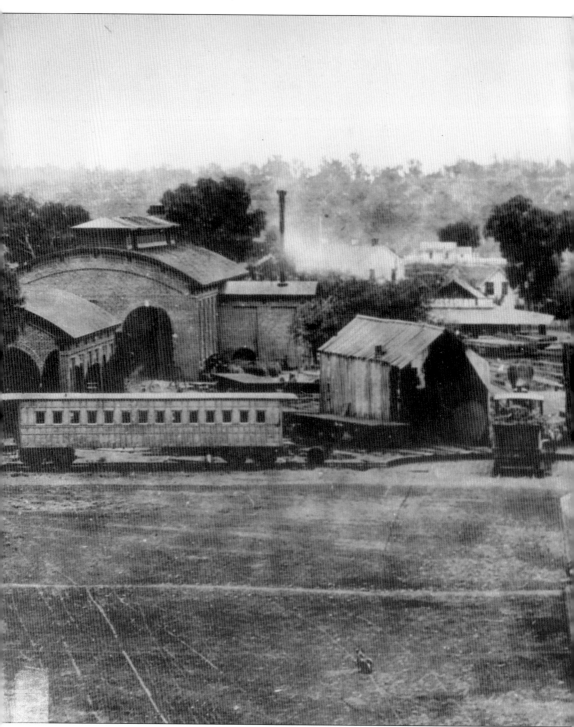

THE SACRAMENTO VALLEY RAILROAD YARD. By 1861, when this photograph was taken, Folsom's railroad yard was an impressive sight and normally a hub of activity, employing some 1,500 men in its extensive machine shops. The building in the left rear was the roundhouse and the brick building on the right displayed this sign: "W.L. Perkins. Forwarding Commission

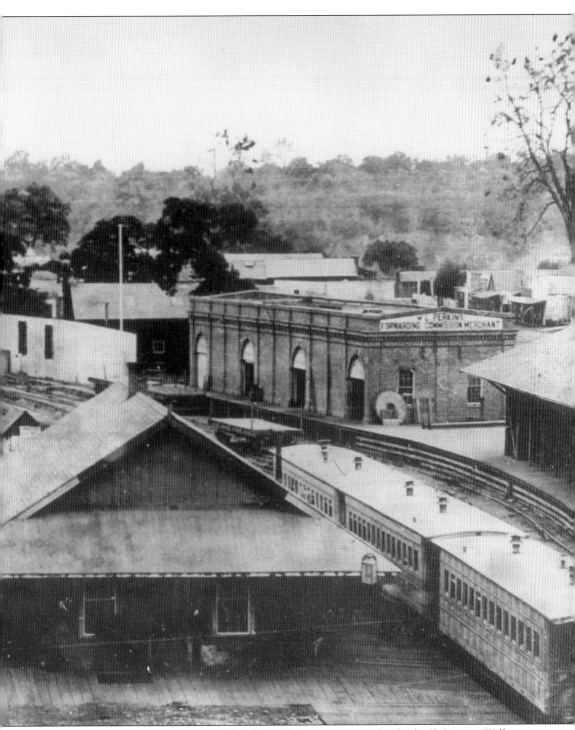

Merchant." To this building's rear lie the old businesses on Leidesdorff Street. William Tecumseh Sherman, one of the SVRR's organizers as well as a director and vice president of the company, went on to a distinguished career as a general in the Civil War.

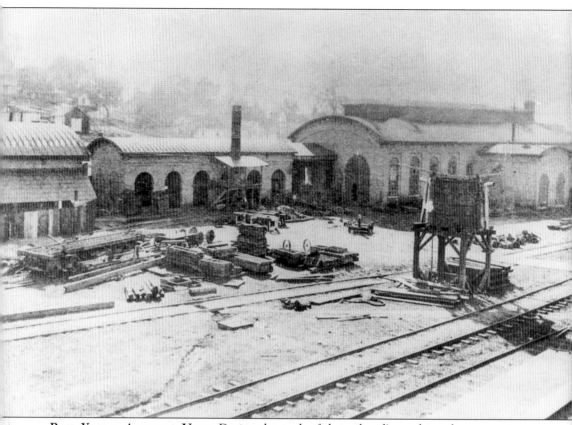

RAIL YARDS, ANOTHER VIEW. During the peak of the railroad's machine shop operations, a couple of freight buildings, a foundry, a paint mill, a carpenter shop, a planing mill, and an engine house occupied the site, in addition to the series of passenger stations. After the original passenger station burned down in 1857, its replacement was up and running by January 1858. In 1889, the passenger station was replaced yet again and a 17,000-gallon water tank was built. Ten years later a water column was added that remained in service until 1958. After standing empty for years, the old machine shop was given new life briefly as a pipe factory in 1889. By 1893, it was being used as a pear-packing shed, and in the spring of 1895, the shops were torn down and their bricks used in the nearby powerhouse. In 1902, the Earl Fruit Company built a packing shed on the site of the shops. The Pioneer Fruit Company also built a packing plant on the site in 1907, but it was eventually incorporated into the Earl facility, which lasted into the 1940s. In 1913, the depot again burned and was replaced the following year. It was enlarged to its present size in 1925.

94

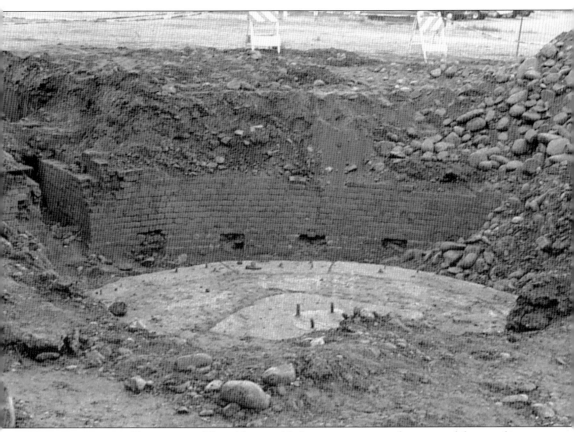

UNCOVERING THE TURNTABLE. The old turntable has an interesting history and future of its own. The original wooden-deck turntable, built in 1856, was replaced once in 1867 and again in 1882. A second turntable installed in 1868 near the carpenter shop was replaced in 1891. A roundhouse was built adjacent to the main turntable in early 1869, and demolished 18 years later. In 1996, the turntable foundation was uncovered in anticipation of the restoration of the railroad block. Folsom photographer Tom Paniagua was on hand to record the event on film.

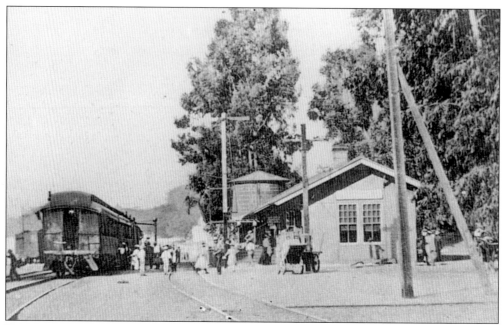

FOLSOM'S SVRR YARD IN 1861. Once the track laying from Sacramento to Folsom was completed, a gala celebration was held. More than a thousand people took the free excursion to Folsom to partake in the exciting festivities.

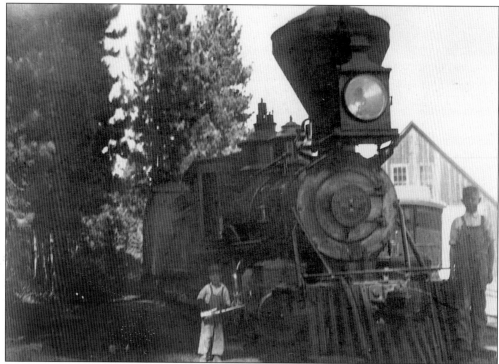

BOYS ALWAYS LOVED TRAINS. Although this is not a Folsom train, local men and boys loved trains, as shown in this photograph of train engineer Ed Saul and his sons, Everett (with the oil can) and Bert.

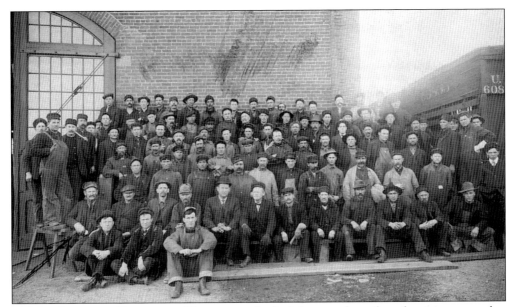

FOLSOM RAILROAD EMPLOYEES. The man on the far left, second row from front, was a member of the Casten family.

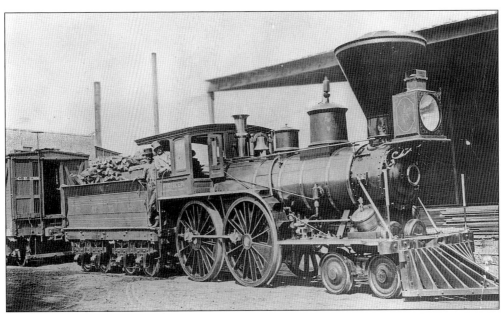

ISN'T IT A BEAUTY? The Globe Locomotive Works in Boston built this beautiful locomotive in 1849. It was shipped around the Horn to San Francisco in 1854 where it was used in grading San Francisco's sand dunes. In 1856 it was sold to the SVRR and named after the railroad's president, C.K. Garrison. Later, its name was changed to *Pioneer* because it was the first locomotive to arrive in California.

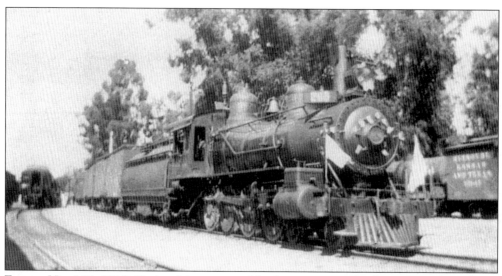

ENGINE NO. 265, 1910. During this era, trains like this one were a familiar sight in the railyards of Folsom. Always evolving, the locomotive has undergone many changes since the early days.

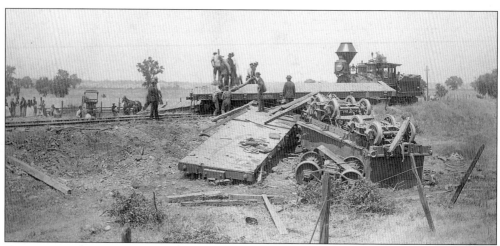

TRAIN DERAILMENT. A group of curious bystanders watch as workers go about the arduous task of cleaning up after a train wreck near Folsom. Notice the rickety fence in the foreground. Do you suppose it could have stood up under the force of the hurtling railcars?

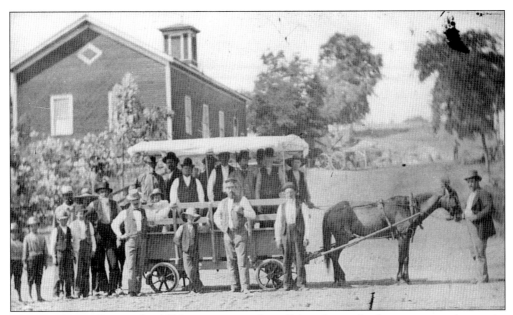

TOURIST BAIT. During the 1880s, excursions along Folsom's riverbanks were a popular tourist attraction. Horse-drawn trolleys regularly traveled from the Folsom depot along the riverbank to the construction site of the old Folsom Dam. This view, looking up Wool Street from the railroad tracks, includes Fireman's Hall to the left. The hall was torn down around 1910. This photo was reproduced from a tintype once owned by Alice Ford, Bill Rumsey's grandmother.

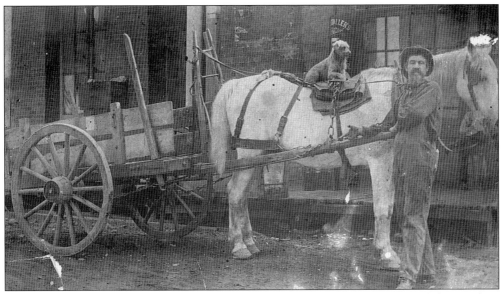

ALL IN A DAY'S WORK. For many, a horse and wagon was essential to accomplishing a day's work. However, Mr. Nichols, pictured here in 1882, was only too happy to take time out to pose with his horse and dog.

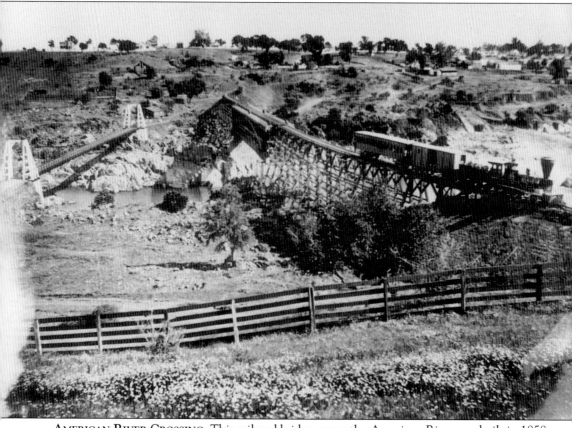

AMERICAN RIVER CROSSING. This railroad bridge across the American River was built in 1858 and served the California Central Railroad from 1860 to 1866. At the time, the bridge, 92 feet above the water and with a span of 216 feet, cost $100,000 to build. The suspension bridge on the left, 50 feet lower than the railroad bridge, was lost to the raging floodwaters of 1862. The railroad bridge trestle was damaged in the center. Considered unsafe, it was condemned in 1866. During its peak of operation, however, trains regularly traversed its course, traveling from Folsom to Roseville and on to Lincoln.

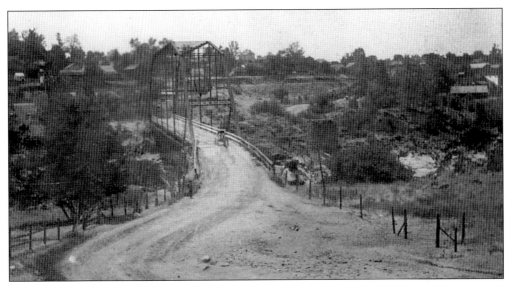

A VIEW ACROSS THE AMERICAN RIVER. This bridge spanning the American River was moved to another site when its usefulness to Folsom was determined to be over. The iron structure bridged the river from 1893 until the 1930s, although traffic was diverted to the Rainbow Bridge when it was built in 1918. The iron bridge will be returning to Folsom to be used as a pedestrian bridge.

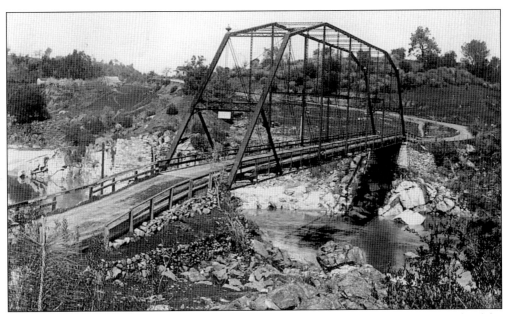

ANOTHER VIEW ACROSS THE RIVER. The photographer was standing on the Folsom side of the bridge looking north when this picture was taken.

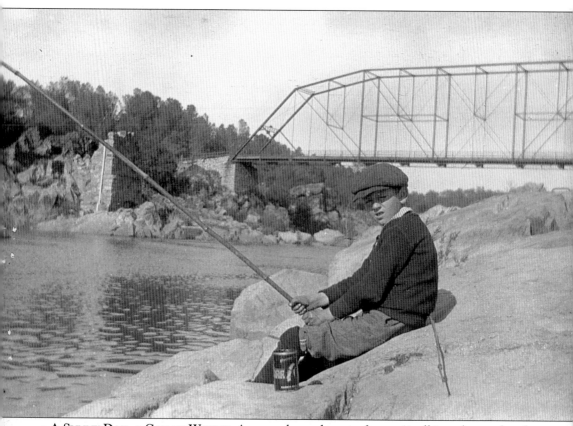

A SUNNY DAY, A CAN OF WORMS. A sunny day and a can of worms is all it took to make a boy happy in 1910. The rocky bank of the American just below the bridge made the perfect spot to laze away a summer afternoon. If you caught a fish, that was great, but if you didn't, that was alright, too. To the left of the bridge is a foundation that held a prior bridge.

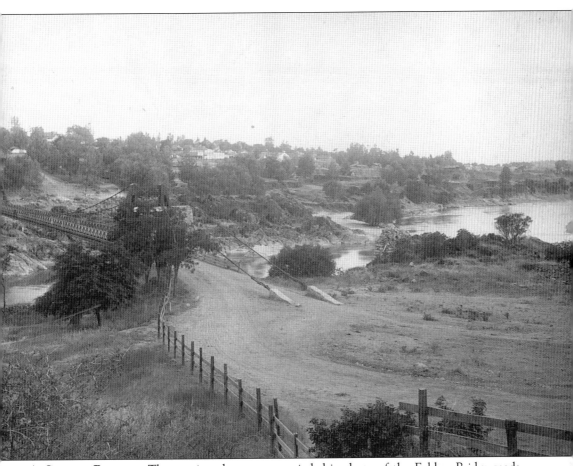

A City of Bridges. The caption that accompanied this photo of the Ecklon Bridge reads, "Folsom, from north side American River taken July 13, 1890. Exposed, developed and finished by myself, W.P. Burnham, Folsom, Sacramento Co., Cal."

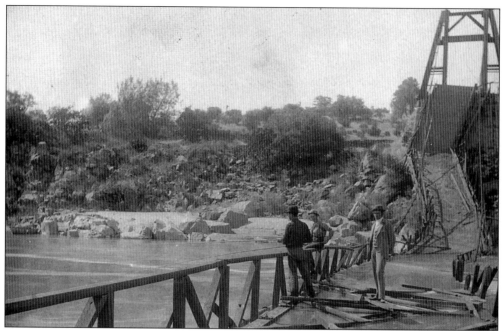

ONE OF MANY DISASTERS. Another photograph by W.P. Burnham, taken in 1892, shows three curious gentlemen fishing off the partially collapsed Ecklon Toll Bridge.

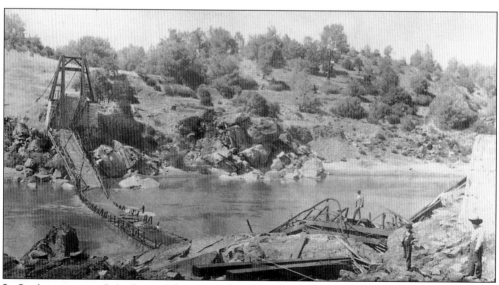

IT ISN'T OVER TIL IT'S OVER. This is another view of the damage to the Ecklon Bridge. The reports said that the suspension cable snapped, but vandalism was suspected. Soon after, the bridge fully collapsed beyond repair. The steel arch bridge replaced it the following year.

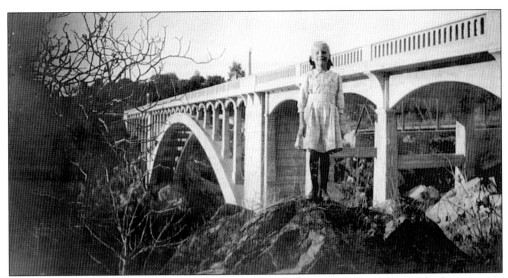

A Portrait in Time. Alice Baker was a young girl when she was photographed on granite rocks beside the Rainbow Bridge in 1925. The spot is still a favorite with photographers. In the background, a truss bridge is visible.

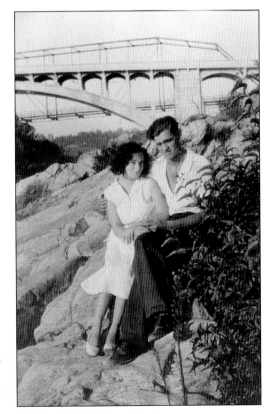

Sweethearts by the Rainbow Bridge. As far back in Folsom history as can be remembered, folks have enjoyed the American River. Today, Negro Bar State Park, located across the river from Folsom, is still a popular place for picnics, and a biking and hiking trail extends along the river from Sacramento to Folsom.

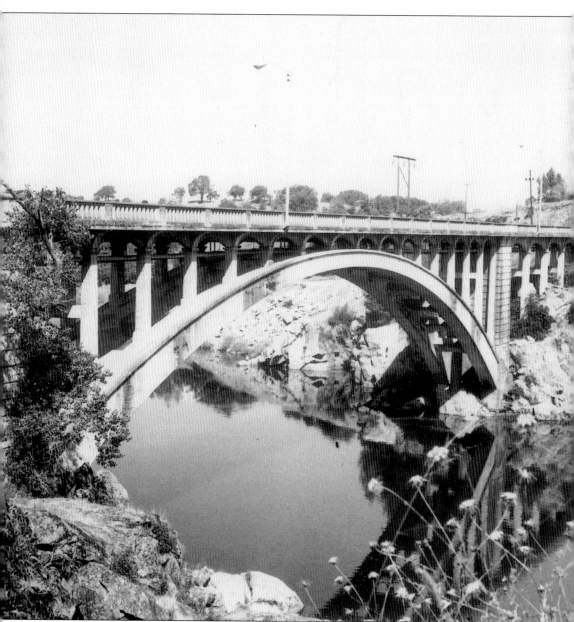

RAINBOW BRIDGE. Built in 1918, Rainbow Bridge has shown that a thing of beauty and strength can stand the test of time and nature. Until the building of Folsom Dam in 1956, the bridge proved itself over and over again against the raging assaults of winter and spring torrents. Today, the faithful bridge awaits its new role as a secondary crossing into Folsom. A new span, nearby, nears completion at the time of this writing.

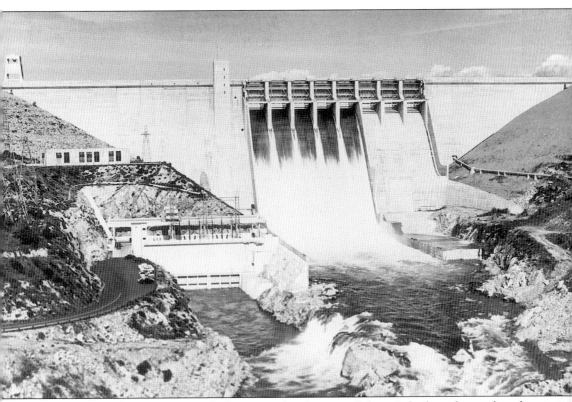

FOLSOM DAM. Folsom Dam controls the waters that flow into Folsom Lake from the north and south forks of the American River. Fourteen miles farther upstream, the middle fork converges with the north fork near Auburn. Measured along any one of these forks, the river is slightly more than 100 miles in length.

For centuries, the American River ran a wild and unruly course from its sources, causing great damage outside the city of Sacramento. The harnessing of the river resulted in a belt of semi-wilderness in the flooded plain that had long defied development. In 1959, the American River Parkway system was created. Today, that parkway includes more than 30 miles of bicycle and hiking trails, picnic grounds, and wildlife preserves.

Stories tell of an 1808 party of Spanish explorers, led by Ensign Gabriel Moraga, naming the waterway the Rio de las Llagas, in remembrance of the wounds and suffering of Christ on the cross. It is believed that Jedediah Smith, traversing the area in 1827–28, named it Wild River, although on 1833 land grant maps it appears as Rio Ojotska, the phonetic spelling of the word "hunters" in Russian. Later maps show it being called Deception River, then Coopers River. John Fremont's map of 1845 calls it Rio de los Americanos.

In 1876, John A. Sutter proclaimed it the American River.

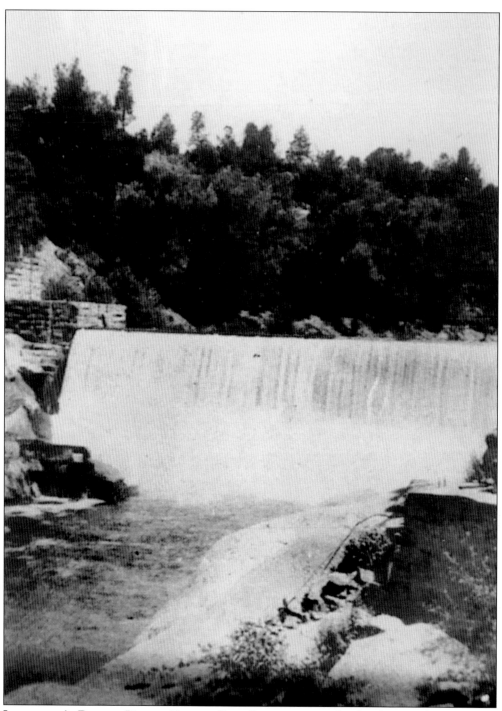

LIVERMORE'S DREAM. Pioneer Horatio Gates Livermore visualized a dam on the American River as early as 1860.

Six

FOLSOM PRISON

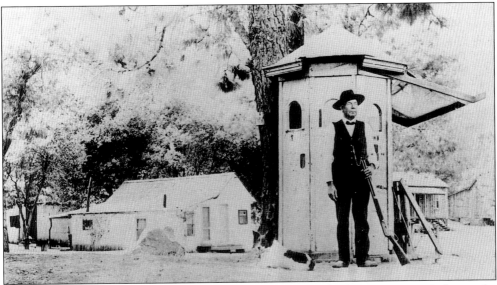

FOLSOM PRISON. This guard hut stood on a small knoll outside the prison grounds during the prison's earliest years. It allowed the guard to watch the convicts in the prison yard as well as any approaching visitors. Visitors were required to report their visitation purpose to the guard before entering the premises. The weapon he is holding is an octagonal barrel Winchester .30.30. The houses visible in the background were common frame dwellings that housed the guards and their families who wished to reside near the institution. The guards themselves constructed many of the houses, since the prison's budget in those years could not accommodate such expenses. Often, upon leaving their employment at Folsom Prison, the guards would move these houses onto lots purchased in the town of Folsom.

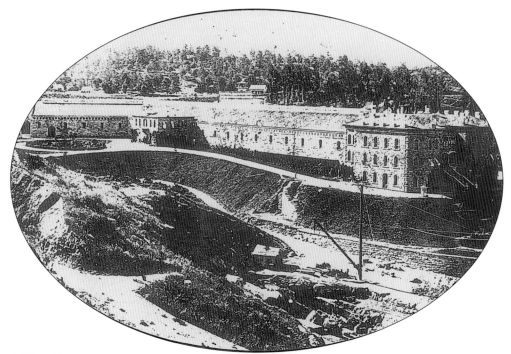

A VIEW FROM THE HILL, C. 1894. This view from above the American River shows the prison grounds looking southwest. The granite quarry used to produce the blocks for the prison's construction appears in the foreground. Originally, it was one of the first operating granite quarries in California. The buildings above the quarry, from left, were used as the kitchen, captain's office, the captain and lieutenant's living quarters, a cellblock known as Five Building, and the administration building, which provided officers and guards living quarters on the third floor, the warden's residence on the second, and left the first floor for multiple purposes.

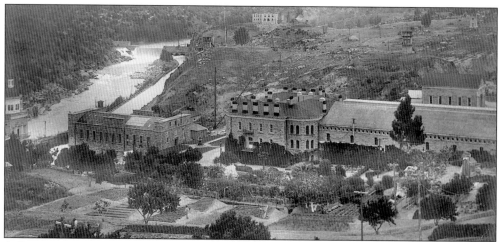

A PANORAMIC VIEW, C. 1910. Pictured in the center is the administration building and Five Building. Other structures added after 1894 are also visible, including, from left to right, the stone tower (1901), powerhouse (1892), asylum for the criminally insane, also called the "Bug House" (c. 1912), and the prison chapel, also called the Greystone Chapel (1900). On the left side is the Folsom Water & Power Company dam and canal.

110

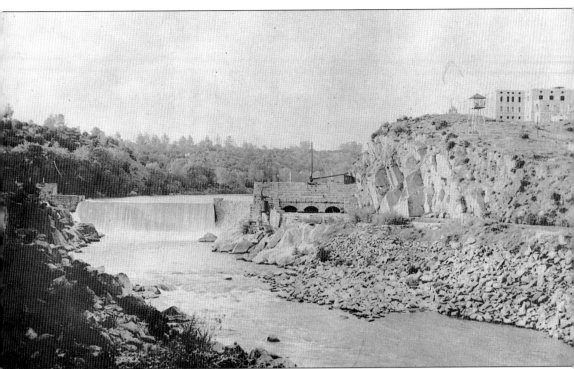

THE FOLSOM WATER & POWER COMPANY DAM AND CANAL HEADGATE, C. 1913. This structure, which wasn't completed until convict labor became available, was used to provide water to the prison powerhouse (1893) and the Folsom Powerhouse (1895), as well as to float logs to the American River Land and Lumber Company's log pond (1896). Overlooking the river and canal in the background is a stilt tower originally built to observe convicts as they ran logs through the headgate on their way to the sawmill. Behind that is the "Bug House." It was never used, due to an ugly brawl in 1914 when four convicts were killed.

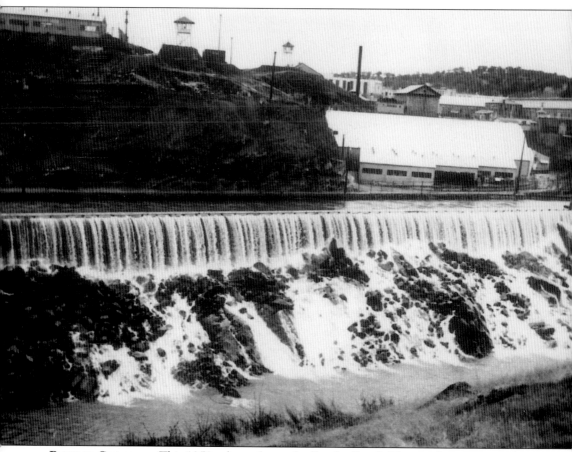

BEYOND CAPACITY. This 1950s photo shows the Pacific Gas & Electric Company canal as it overflows its banks. Originally built by the Folsom Water & Power Company in the 1890s, the canal was used by the power company's successor until the closure of the Folsom Powerhouse in 1954, when the U.S. Army Corps of Engineers completed the new dam and lake. During construction of the new dam, the canal was used by diverting water from the American River's natural bed through diversion canals, which flowed down into the old canal. Prison structures in the background reflect the changes of time and progress.

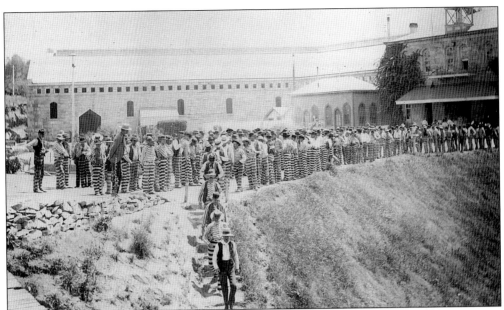

MEN IN STRIPES, C. 1880. The granite quarry at Folsom Prison was in continuous use from 1873 until around 1915. This early photo shows convicts lined up to start their shift at the quarry. Notice the variation of stripes used for the convicts' suits. "Con Bosses," men who were most trusted, wore white shirts, black pants, and vests. Inmates with all horizontal stripes were regular convicts, also called "Bottom Feeders," which is where their food came from out of the mess bucket at mealtime. Those inmates who wore vertical striped pants and horizontal striped shirts were of a slightly higher caliber and were called "Beef Tables," eating a bit better at meals than the regular inmates. The convict "Subguards," those who assisted the freemen guards, wore vertical striped pants, white shirts, and a vest.

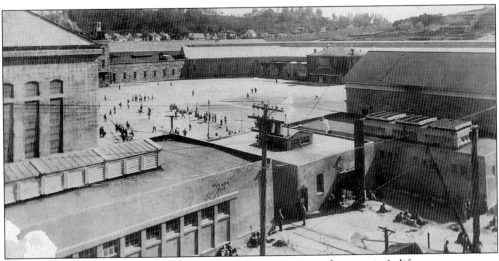

THE BIG YARD. Except for the few who had connections, the convict's life was a constant struggle for survival. Their diet was less than desirable and hygiene was nearly impossible. Baths and clean clothes were rare luxuries and medical attention, except for those near death, was almost unavailable. Conditions had improved immeasurably by 1956, when this photograph was probably taken, and inmates were taken to the "Big Yard" for recreation.

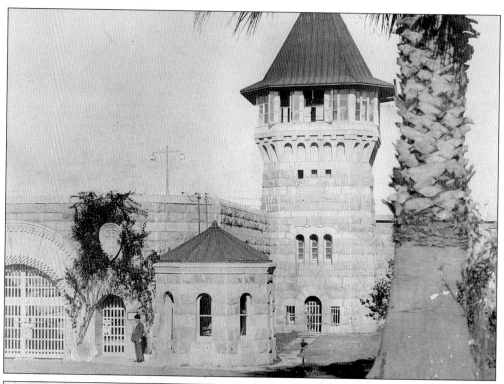

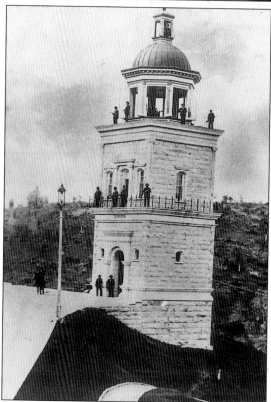

EASIER GETTING IN THAN OUT. The East Gate, or main entrance to Folsom Prison, pictured here around 1931, was used as the main guard post along the old Coloma Road, which led from Folsom to Coloma in El Dorado County to the east. The heavy iron gates, the double gate for vehicular entrance, and the small single gate for pedestrian access remain in place today, their clanking heavy metal resonance when closed a reminder that getting into Folsom Prison is easier than getting out. The East Gate tower, Tower No. 1, also serves at the prison's armory.

AN INTIMIDATING SIGHT. Tower No. 13, *c.* 1880, was originally located on the old Coloma Road and greeted visitors as they approached the prison. One of the largest towers erected, it served as a Gatling gun post, an observation post overlooking the quarries (center walk) and guard living quarters (lower floor), and contained cells beneath.

IMPRISONED IN VINES. The Administration Building, or Officers and Guards Building as it is commonly called, is pictured here around 1911. The old car parked in front belonged to Warden William H. Reilly, who served from 1908 to 1912. This building, built in 1894, served a number of purposes: the top floor was used for guards quarters, the warden's residence (previous to 1910) was located on the second floor, and the ground level area was used first as a carriage house and later as a garage. Hidden by the long rising steps is the front pedestrian entrance into the ground-floor facility.

IT'S NOT THE RITZ. The interior of No. 1 Dining Hall appears in this 1950s photo. Built in the mid-1950s, it is the largest of the dining halls and located off of Building No. 1. Every table was set previous to the dinner call.

DIG IN, BOYS. This is the original dining hall, now called No. 2 Dining Hall, as it appeared in the 1880s. Plates used by the regular inmates, those not considered "Con Bosses" or "Subguards," were attached to the tables, where their food was dished to them from buckets. After each meal, the plates were "cleaned" using buckets of water and brooms with which to scrub them. After they were scrubbed, they were rinsed with more buckets of water. The empty tables in the foreground were where the "Con Bosses" sat to eat.

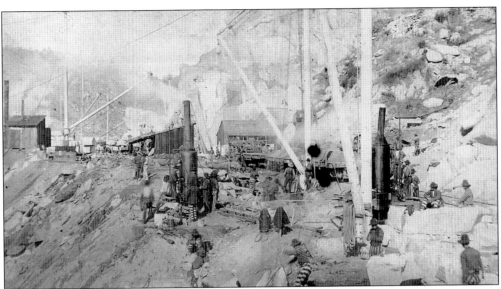

THE PRISON QUARRY. In 1889 the prison quarry yard was located on the western boundary of the prison near Robber's Ravine, so-called for the number of robberies that took place there in the mid-1860s. Featured in this photo are steam donkeys, which powered the drills used in quarrying the granite stone, called "rough quarry." The building in the center was the rock crusher. It crushed the waste granite produced into decomposed granite for use on roads. To the left are the finishing sheds where the granite was "dressed" before leaving the quarry on the main railroad track leading to Folsom. Note the differences in the dress of the three convicts pictured on the lower right.

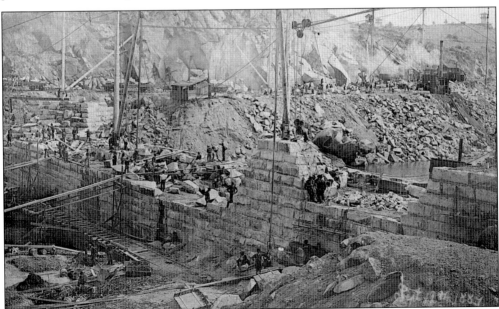

POWERHOUSE CONSTRUCTION, 1889. Work began in enlarging the dam and completing the canal in mid-1889. It was planned in conjunction with the American River Land and Lumber Company's historic sawmill, located west of the prison on the eastern boundary of Folsom. The first stone for the powerhouse was laid in March 1890.

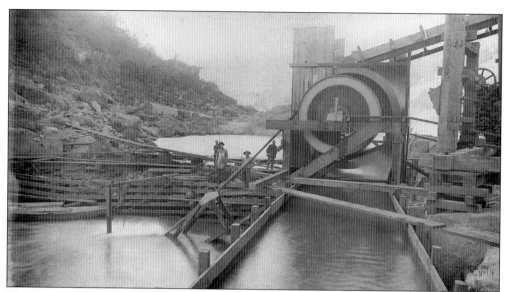

THE FOLSOM PRISON DAM.

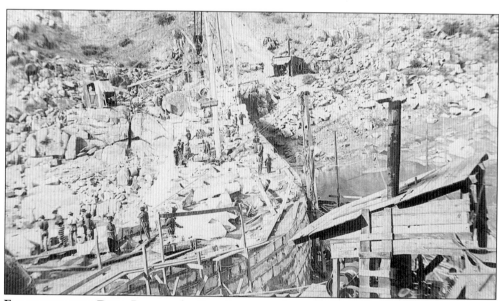

ENLARGING THE DAM. Because the first dam proved too shallow for the high waters of the American River during earlier flood years, the structure was enlarged beginning in 1889. Through its agreement with the state, the company leased the convict labor used to perform these innovative tasks. A steam donkey was placed on each side of the river to assist in these efforts, and sheds were built over them to house some of the inmates.

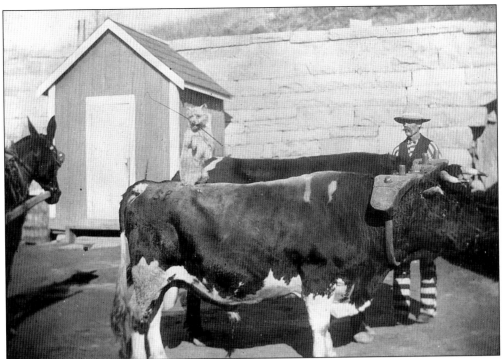

ANIMALS AT THE PRISON. These oxen hauled the granite blocks used in the construction of the prison wall, which began in 1907. The little dog sitting atop the ox belonged to the guards who kept it with them at their portable quarters (the building in the background). Note that the building is on skids, allowing it to be towed to each new location as the wall's construction progressed.

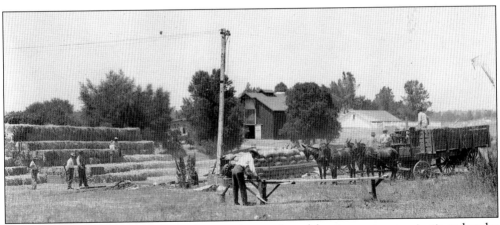

THE PRISON RANCH. Folsom Prison's extensive ranch and farming system was instituted under Warden Charles Aull (1886–1899). Under instructions from the Board of Prison Directors, the warden established the land around the prison yard as a completely functioning agricultural endeavor. This scene of activities at the "Ranch" was probably taken sometime after 1914, when the use of striped inmate suits was discontinued. The men are in the process of harvesting the hay, which was used for animal feed and inmate bedding fill. The location of the barn in the background was the site of the second cemetery used at the prison. The cemetery was relocated in 1913 to allow the ranch to be expanded.

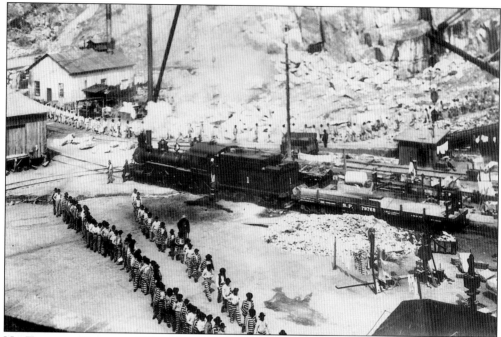

NO TRAIN TO FREEDOM. Folsom Prison's "upper quarry" may have been the original site of the Griffith Quarry, established in the early 1850s. The finished granite blocks loaded in the flatcar were used for cemetery plot ornamentation. Inmates dressed in striped suits date this photo as pre-1914. In 1903, the Board of Prison Directors ordered Folsom Prison to halt shipments of dressed granite in competition with private enterprise.

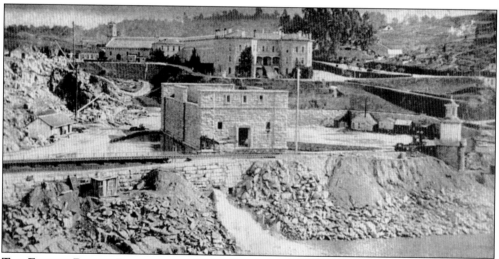

THE FOLSOM PRISON POWERHOUSE. This official photograph was used by the state in its 1893 edition of the secretary of state's "Blue Book," documenting the current state of the various agencies of the government. Pictured to the left of the powerhouse is an inmate house used by the canal gatekeeper. From the far right to left is Tower No. 6, the blacksmith shop, used by Albert Ball in 1895, and the site where convict Lloyd Samsell hid out during his 1920s escape attempt. At the far left are a quarry dressing shed and the quarry offices. The Officers and Guards Building prominently stands in the background.

A Tower Guard.
George H. Eveland worked at Folsom Prison from November 1891 until March 1900. Born in 1870, Guard Eveland would later marry Emma A. Miller, the daughter of prominent Folsom pioneer furniture dealer and undertaker Jacob Miller. During his days at Folsom, he was assigned to a Gatling gun post in one of the lookout towers. George died in 1948 and is buried in the Miller family plot at a local cemetery.

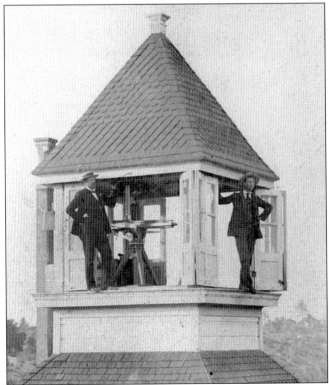

Guns and Guards. George H. Eveland poses next to the Gatling gun in this pre-1900 photograph. The Gatling was an early version of the machine gun. The other man pictured is P.J. Cochrane, who began his guard duty in December 1891 and became captain of the guard in 1905. Cochrane was later killed in an accident at the quarry.

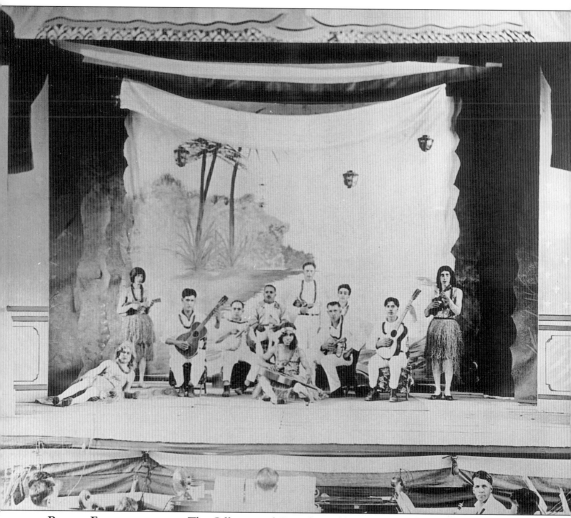

PRISON ENTERTAINMENT. The Officers and Guards Building became the social centerpiece for those at the prison and from the surrounding community. Hollywood production companies often provided costumes for convict performances. This photograph, taken around 1900, shows one of the inmate productions that was staged in the dining room of the Officers and Guards Building, including inmates dressed as Hawaiian maidens. Other social activities produced with the inmates were held each Fourth of July when guests, dignitaries, and members of the local community were invited to observe competitive sports games among the prisoners.

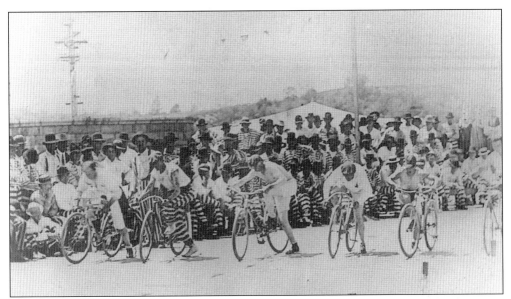

ON YOUR MARK. Bicycle racing was a favorite part of the Fourth of July festivities on the prison grounds. Photographed here around 1913, inmates eagerly wait for the starting gun to fire.

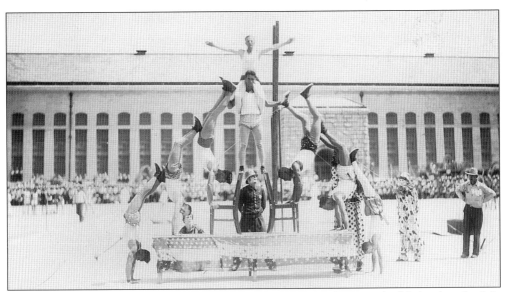

A PRISON VAUDEVILLE ACT, 1931. Displays and feats of agility were highlighted at the July celebrations. The audience seated in the background shows what a large turnout these functions enjoyed. Folsom Prison shows and celebrations became the highlight of social activity within the local community.

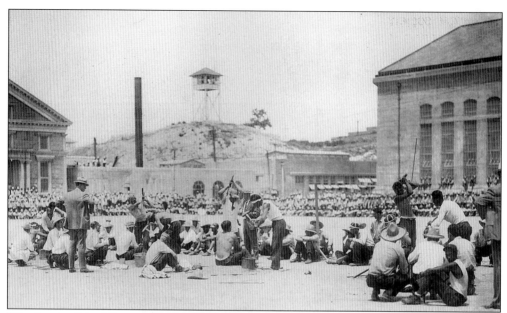

WHO'S THE BEST? Festivities and performances at Folsom Prison were daylong affairs, lasting until the dinner hour. Despite their laborious efforts in working the prison's quarries, inmates competed in drilling contests to show off their skill at their jobs. This performance took place *c*. 1930.

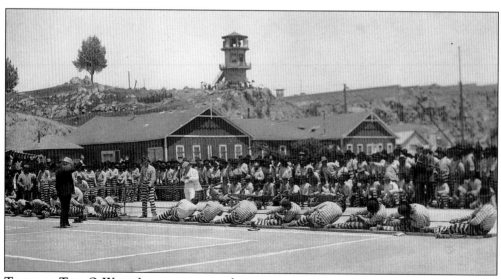

TIMELESS TUG-O-WAR. Inmates in striped suits compete in a tug-o-war contest during the 1910 Fourth of July Celebration. The man in the black suit is the captain of the guard, P.J. Cochrane, who is shown officiating at the function.

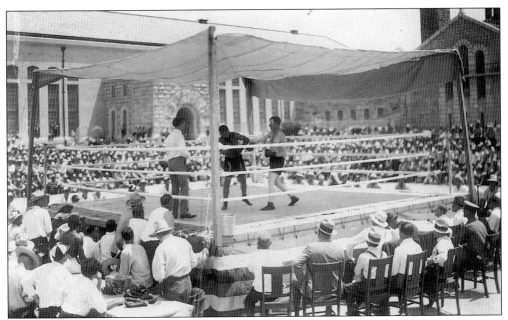

THE FIGHT'S LEGAL. Boxing matches became a favorite attraction at Folsom Prison's festivals during the 1920s. These convicts duke it out for fun on this day, even though fighting is a common, daily occurrence behind the gray walls of Folsom Prison.

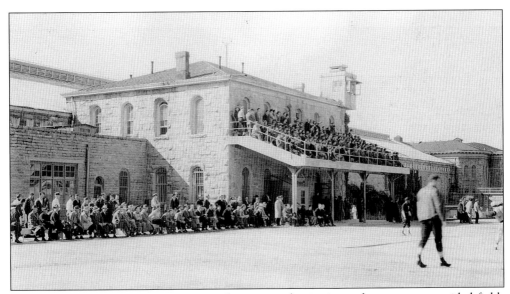

A BIRD'S-EYE VIEW. Spectator seating for visiting dignitaries and guests was provided field-side. The more important guests of the warden were seated on the balcony of the captain's office and were afforded a bird's-eye view of the action.

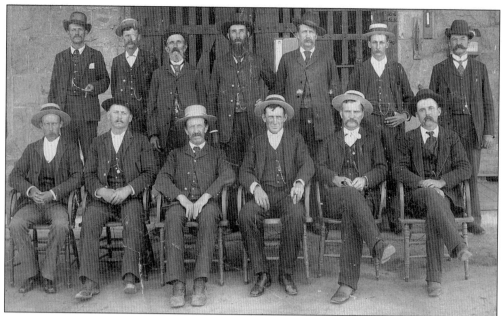

THE FOLSOM PRISON STAFF, C. 1900. This staff photograph includes Folsom pioneer Charles H. Jolly (seated far left), Capt. P.J. Cochrane (standing, third from right), and George Eveland (standing, second from right). The man standing in the center may be Edward Aull, the nephew of Warden Charles Aull. Charles Jolly came to California in November 1858. By 1866, he was a partner in a Folsom grocery store, obtaining sole ownership by 1872. In August 1886, Jolly's store was lost to a devastating fire that destroyed much of the central business district. In 1893, Jolly was appointed to the prison guard staff. During his employment at Folsom Prison, he rose to the rank of lieutenant of the guard, but as he grew older, he was given less taxing responsibilities. Jolly was continuously employed at the prison until his death in 1926 at the age of 89.

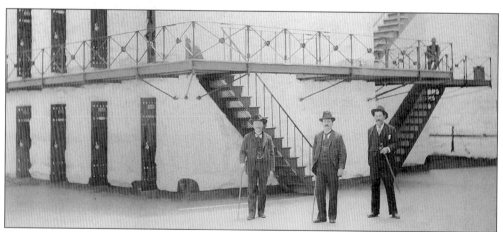

THE INTERIOR OF FIVE BUILDING, MID-1890s. The guards are not identified, but each carries steel tipped canes which were used to discipline convicts who got out of line. These canes were later outlawed by the state and replaced by wooden batons similar to those still in use by law enforcement officials today. Note that the cellblock in this photograph does not touch any exterior wall; the cells were built in this fashion to prohibit escapes from the facility by limiting access to the outside world.

VALLEY HOUSES AT THE PRISON. Twelve-hour shifts worked by the guards each day precipitated the need to erect housing near Folsom Prison. The state provided the building lots, but in the earliest years the guards were required to provide the dwelling structures. The residences were erected in what came to be called the "Valley" and were called "Valley houses." These homes, some of which remain today, were located just south and east of the main entrance to the prison yard. Today's staff, who still may reside there, is required to pay rent to the state for their housing. Guards who resided in the "Valley" were required to provide "first response" to inmate incidents that occurred inside the prison. The same requirement remains true today.

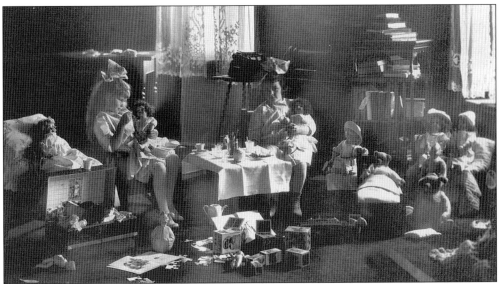

THE CHARM OF CHILDREN. Surrounded by a roomful of toy friends, these little girls are believed to be the daughters of Warden Reilly. Children who grew up at Folsom Prison and Represa were taken to school in town and returned each afternoon via the prison "stage." A motorized bus did not replace the prison's two-horse stage until 1920, so the experience of modern bussing did not reach the lives of the children of Folsom Prison for many years. There is still no school for the families living in the "Valley;" instead, a yellow school bus arrives each morning to transport them to school.

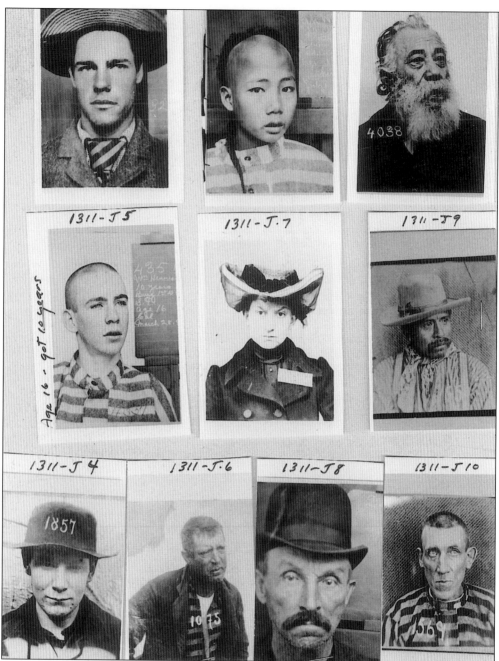

PRISON MUG SHOTS. These "mug shots" were taken of various prisoners and usually mounted in the "mug books" held in the administration offices. Oftentimes the lieutenant and captain of the guards needed to have access within their offices, thus copies of the photos were pinned to the walls throughout the years. Later officers inherited some of these photographs, and had them framed and mounted in their offices as memorabilia. Notice that there is one woman featured in this collection. Women prisoners were few and far between at Folsom Prison, but over the years, 26 women prisoners called the prison home. They were housed in an area in the Officers and Guards Building, and worked at housekeeping tasks and as maids.